First Edition 2012
Published by the International Center of Photography, New York

SHIFT Vol. 7

© 2012 for this edition: International Center of Photography, New York

Creative Director: Alison Morley
Design Director: Rhona Bitner
Photo Editor & Project Manager: Romina Hendlin
Director of Publications: Philomena Mariani
Managing Editor: Eli Spindel
Production Manager: Per Gylfe and the ICP Digital Media Lab
Postproduction: Matt McDonough
Printer: Brilliant Graphics, Exton, Pennsylvania

ISBN 978-0-933642-10-2

International Center of Photography
1114 Avenue of the Americas
New York, NY 10036
www.icp.org

ORDER DISORDER

Shift Vol. 7

ACKNOWLEDGMENTS

We would like to acknowledge the following faculty who are a rich part of our community and whose efforts can never be overvalued:

Shelby Lee Adams, Paula Allen, Bill Armstrong, Alexandra Avakian, Nelson Bakerman, Marina Berio, Rhona Bitner, Robert Blake, Nayland Blake, Corinne May Botz, Jean-Christian Bourcart, Liz Brown, Clinton Cargill, Elinor Carucci, Jean Marie Casbarian, Pradeep Dalal, Moyra Davey, David Deitcher, Liz Deschennes, Amadou Diallo, Deirdre Donohue, Cecilia Dougherty, Mark Alice Durant, Joy Episalla, Giorgia Fiorio, Allen Frame, Frank Franca, Ben Gest, Ashley Gilbertson, Eric Gottesman, Susan kae Grant, Edward Grazda, Lori Grinker, Per Gylfe, Ron Haviv, Marvin Heiferman, Neal Jackson, Jeff Jacobson, Bill Jacobson, Susan Jahoda, Lamia Joreige, Sean Justice, Michael Kamber, Jesal Kapadia, Ed Kashi, Nina Katchadourian, Leeor Kaufman, Stephen Korns, Justine Kurland, Joanna Lehan, Judith Levitt, Serge J-F Levy, Andrew Lichtenstein, Mary Lum, Joshua Lutz, Santiago Lyon, Jay Manis, Tanya Marcuse, Mary Ellen Mark, Karen Marshall, Robert Marshall, Matt McDonough, Abraham McNally, Miki Meek, Sabine Meyer, Darin Mickey, Greg Miller, Alison Morley, Carlos Motta, Suzanne Opton, Christopher Phillips, Sylvia Plachy, J.John Priola, Barron Rachman, Emma Raynes, Andreas Rentsch, Eugene Richards, Joseph Rodriguez, Tricia Rosenkilde, Marcel Saba, Bob Sacha, Alessandra Sanguinetti, Joachim Schmidt, Carrie Schneider, Abigail Simon, Stephanie Sinclair, Victor Sira, Claudia Sohrens, Carol Squiers, Tema Stauffer, Maggie Steber, Harvey Stein, Robert Stevens, Scott Thode, Francesc Torres, Jonathan Torgovnik, Bradly Dever Treadaway, Janaina Tschäpe, Hank Willis Thomas, Penelope Umbrico, Gerard Vezzuso, James Wellford, Tom White, Julie Winokur, Bernard Yenelouis, Brian Young, and Quito Ziegler.

From the earliest days of the International Center of Photography, and very much in keeping with the vision of Founding Director Emeritus Cornell Capa, the vitality of the institution has been driven by a strong synergy between the Museum and School. Not only a place where pictures are exhibited, preserved, and researched, ICP is also very much alive with students from all over the world, learning to use photography as a means of communication and personal expression.

Located on a campus in Midtown Manhattan, ICP stands among the nation's foremost institutions dedicated to preserving the past and ensuring the future of photography as an art form. One of the major facilities of its kind, ICP presents more than twenty exhibitions a year, featuring works by photographers from around the world as well as works from its collection of 100,000+ original prints. With an extensive array of historical and contemporary photographs, these presentations reveal the power and diversity of the medium, from nineteenth-century photography to digital imaging.

As the photographic medium undergoes a fundamental reinvention, ICP is proud to expand its role as a leading proponent of all aspects of photography and new media. Central to ICP's educational philosophy is the integration of the history, theory, and practice of photography, coupled with an examination of the multiple forms through which vision, information, and ideas are structured and communicated. Students at ICP may choose to enroll in individual Continuing Education classes, yearlong Full-Time Certificate Programs in General Studies or Documentary Photography and Photojournalism, or the two-year ICP-Bard MFA Program in Advanced Photographic Studies. All of ICP's students have access to unparalleled photographic resources — including digital facilities and traditional darkrooms — and contact with some of the most accomplished instructors in photography and documentary practice.

ICP offers an extraordinary community in which photographers of promise and dedication are encouraged to explore their capacity for creative direction. We invite you to acquaint yourself with all that ICP has to offer.

Willis E. Hartshorn
Ehrenkranz Director

This year I am once again struck by the dazzling diversity and endless possibility that is on display in the pages of this publication, the work of our most talented and dedicated student body during the 2011–2012 year.

From its earliest days, ICP was conceived as a center of photography, a place where collections, exhibitions, and education all collided in ways that were both unanticipated and welcomed. To invite a community of young practitioners into an institution that is dedicated to the display and interpretation of a specific segment of the arts — photography — shouldn't be such a radical intervention. But, in fact, it is. For it suggests that the future resides in the work being produced now, that students can learn from a direct connection to exhibition and collection activities — that the medium is one of invention, discovery, and rediscovery.

It is the diversity of voices, the range of styles and approaches, that makes ICP and the work published here stand out. This year, students from four continents and forty-seven different countries became a part of ICP's community through our three full-time programs. They brought to ICP a willingness to consider the past in relation to their future, an openness to reinventing themselves, and a readiness to be turned upside down and inside out. I believe their work speaks to this transformation.

ABOVE: Freya Ingrid Morales Albalá RIGHT: Sara Skorgan Teigen

Being a photographer is unlike being an artist in most other media in that it begins with an engagement with the world as it is. Photography encourages a synthesis of a range of practices, demands an understanding of multiple disciplines, but does not dictate a prescribed, unified outcome. Rather, it allows the photographer extreme latitude to shape photographs into a world of meaning and intent.

I salute these students gracing the pages of *Shift* for their willingness to imagine the possibilities that photography engenders. I admire them for their embrace of our rapidly evolving medium and continually changing world. And I applaud their skill in creating from this seemingly chaotic stream work of order and understanding. They began the program at ICP on a journey of discovery and opportunity. They have paused here to reflect and share with us some of their findings. They will move on to new horizons. I look forward to celebrating their work as the journey continues, well into the future.

Phillip S. Block
Deputy Director for Programs,
Director of Education

When I make a photograph I want it to be an altogether new object, complete and self contained, whose basic condition is order — unlike the world of events and actions, whose permanent condition is change and disorder.

Aaron Siskind

Shift our annual compendium of student work, is in its seventh year. My colleagues Marina Berio, Chair of the General Studies Program, and Nayland Blake, Chair of the ICP-Bard MFA Program in Advanced Photographic Studies, and I chose order/disorder as the theme for this year's volume, which we felt was a familiar yet complex concept, one broad and deep enough to invite a variety of photographic practices. The entire graduating class met this challenge with genuine moments of understanding and exploration. Our students worked to create magnificent and provocative photographs that fall into such genres as environmental portraiture, still life, photojournalism, landscape, collage, and tableau.

Chaos: The score upon which reality is written.

Henry Miller

It is an appealing idea that the camera seeks order, that we have a tool that allows us to keep from being overwhelmed by the enormous complexity of the world as it unfolds before our eyes. We seek order and pattern in the chaos of our experience. Some pictures are noisy with the clash of ideas and expectations. Some pictures are a surprise — in what we see in the frame and again in what is indicated beyond. All archives contain elements of order and disorder. Formally, the work here is ordered to resist its own linearity. You never go directly toward an end; you pause, muse, construct a narrative perhaps, and move forward. Associations take you away from an interim goal or leave you with an intuitive sense of direction.

The book begins with a figure masked in a whirlpool of cloth reaching out into a vast sky of disorder. What a wonderful image to challenge the entire framing of order/disorder in photography, which attempts to make order out of the disorder of life even if the result is chaos. The transition to architecture in the second photograph restores faith in order as the defiant gesture of a tiny figure literally pushes back the frame. A turbulent ocean wave crashing on a broken sandy shore follows as the place where order meets disorder.

Describing photographs may diminish them if we try to force them into simple categories or even broad ideas like order and disorder. Only in fits and starts do we glimpse order in blown hair, in dark strokes of shadow and strands writing in the calligraphy of the natural world.

Describing evoked feelings is even more difficult. We see people alone, in a room or standing at attention, even wrestling with sheets. There are people placing themselves in a montage of reflection. A street is crowded with people looking for something other than each other; there are neighbors in their backyards whose homes are separated by a narrow space, but the gulf between their lives is much wider. Not only do we see the dreamer in a snooze at a library, we see the dream. Disorder follows order.

Here are portraits of people doing nothing and feeling everything, thoughts floating above their heads like a giant balloon on a string. We see people engaged in the disorderly conduct of protest and conflict, others engaged in the steady disorderly activity of aging.

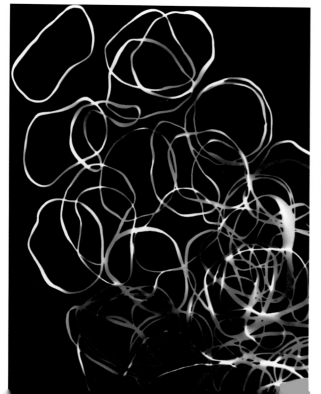

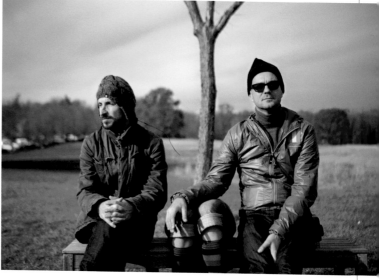

LEFT: Roberta Trentin ABOVE: PETER SNADIK OPPOSITE: SHAYOK MUKHOPADHYAY

Not far down the street outside our Midtown campus, our students photographed activities that came to be known as Occupy Wall Street. For some students, it also became "Occupy My Eyes" and "Occupy My Mind." There are views of distraught people, people in uniform, others restrained and led off beyond the frame. We see a pleasant-looking young woman holding a mirror upon which has been written in lipstick "I Am You." A far more harrowed young woman is on a rolling stretcher, photographed in a way that suggests anxiety, fear, and … disorder.

> *To think for yourself you must question authority and learn how to put yourself in a state of*
> *vulnerable open-mindedness, chaotic, confused vulnerability to inform yourself.*
>
> Timothy Leary, *How to Operate Your Brain*

There are photographs here that insist on being documents. They contribute information about the world and what is known. A photograph can not always escape the moment of its making.

There are birds launching themselves in a feathered flurry of disorder, followed by blurred moving groups on either side of a tall still man wearing a large head of a chicken, then three plumed models gazing while posed for display. Another lies on the floor looking into a mystery under a bed. Next, a man staring at a blank wall in a trash-filled room seems to disappear into it. Birds are seen again floating serenely disordered above an empty playground in a park.

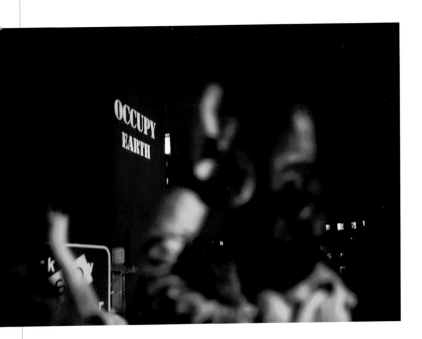

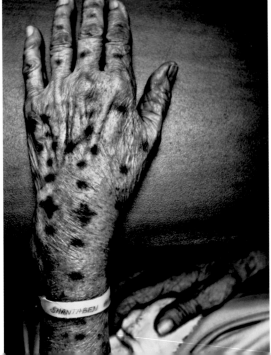

ABOVE: Adrian Jacob Fussell RIGHT: Abhinav Sanghi OPPOSITE: Beth Levendis
FOLLOWING PAGE: Rony Maltz

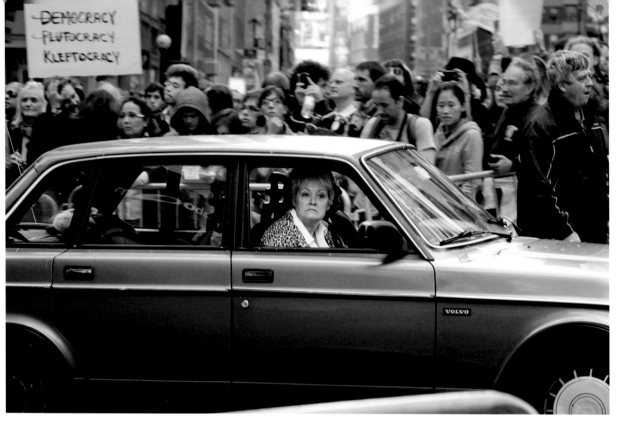

Order is never observed; it is disorder that attracts attention because it is awkward and intrusive.

Eliphas Levi

Toward the middle, we find light, beauty, love, laughter, power, and order. A 99¢ Dreams Store proclaims to vacant spaces in an abandoned mall everything is $1 and up. A fire leads us to the unpredictable temperament of nature itself. A raccoon's eyes caught in a tree meet the eyes of a man in the night.

We have not only the collections of pattern but also the patterns of collection.

These are the hints and clues that civilization is not random. A massive shiny colorful truck and its perfect reflection is not an accident. The missing deck of a boat balanced on its side frames the quiet chaos of an ocean view. The camera again finds order. It seems that in any direction, the photographer can identify traces of civilization — in collections of faces, architectural traces, and refrigerator doors with the packages and containers they carry.

Last, an alphabetic code and a neatly stacked pile of paper gives us a certain reassurance of something attainable. It is hard to see too little, difficult to make a picture too simple.

You need chaos in your soul to give birth to a dancing star.
Friedrich Nietzsche

We are proud to honor our entire graduating class with this book as their work shifts toward the next stage of its development. We hope you enjoy viewing the many different perspectives on order/disorder — a timely and encompassing theme, a theme the students made their own. Thank you to the 2012 class of the International Center of Photography for an inspirational year. Truly a treasured memory for us all. Well done.

Alison Morley
Chair,
Documentary Photography and Photojournalism Program

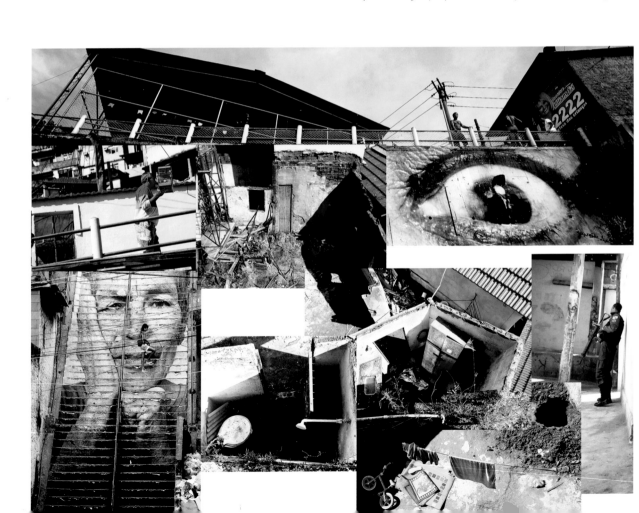

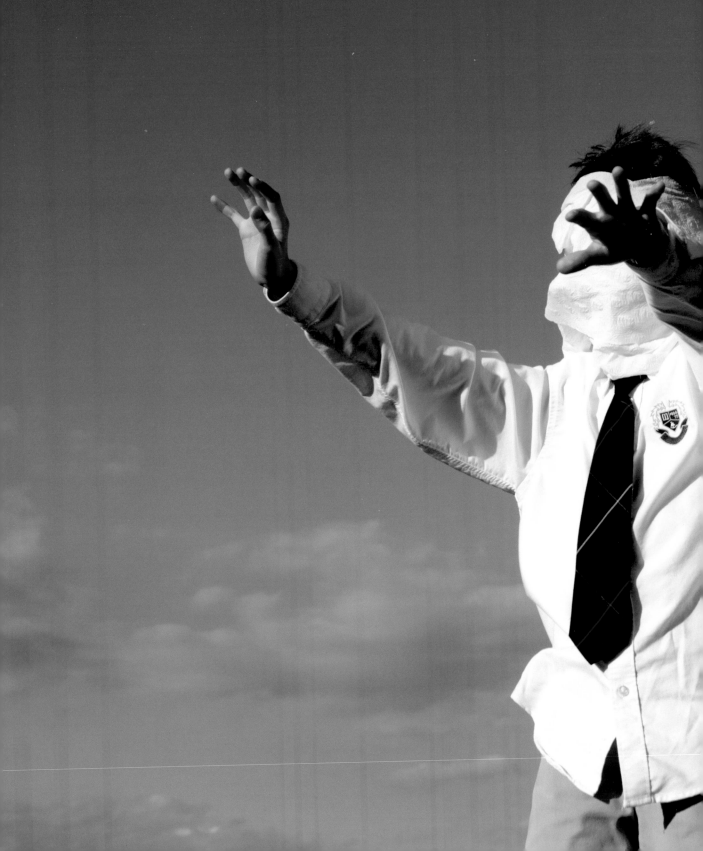

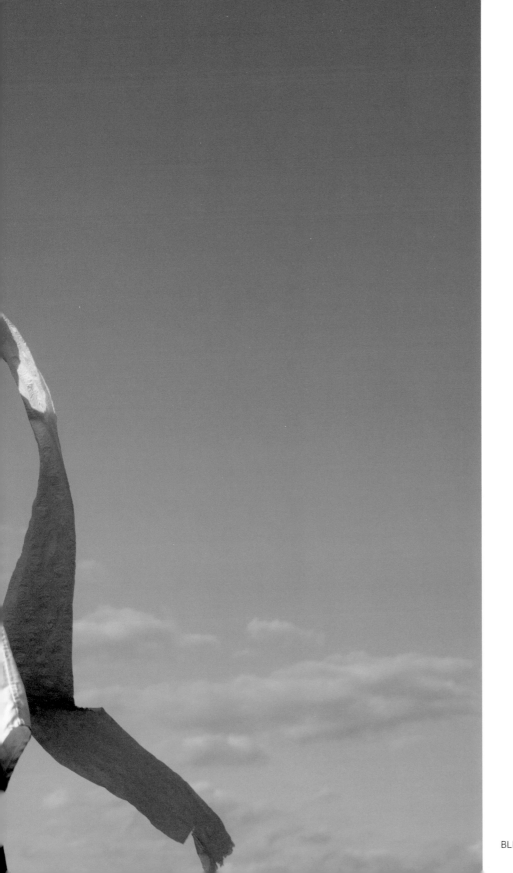

Elena Soboleva

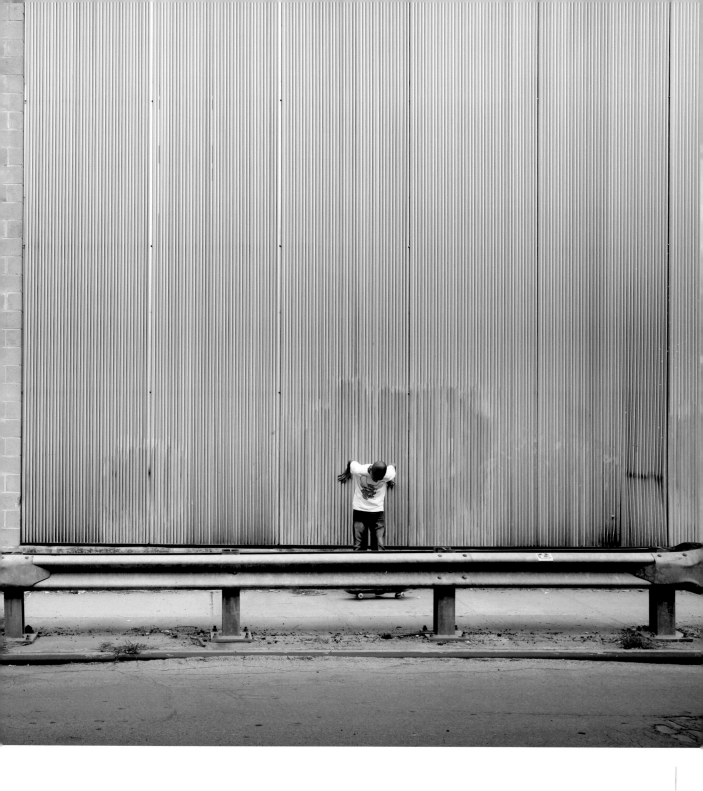

John D. Braiman

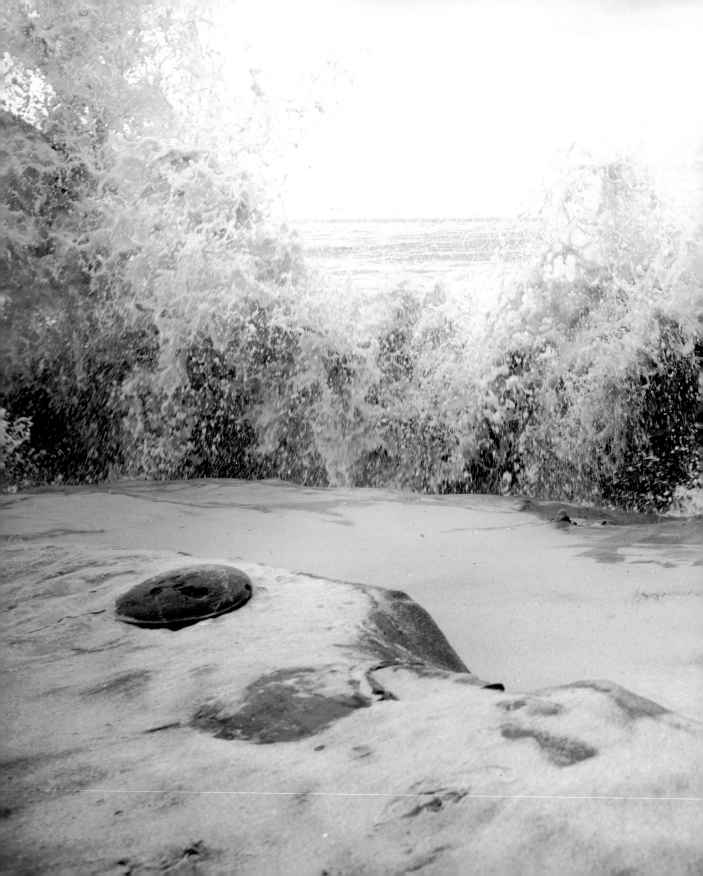

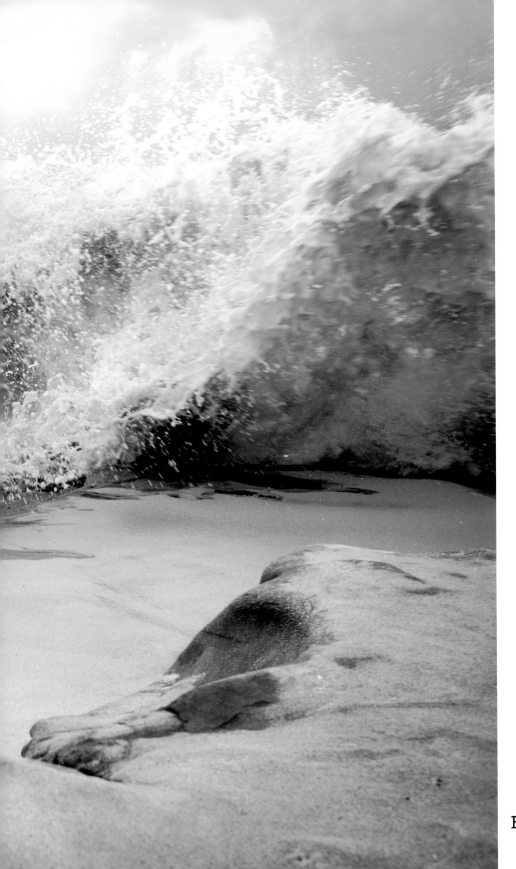

Robin Lee Dahlberg

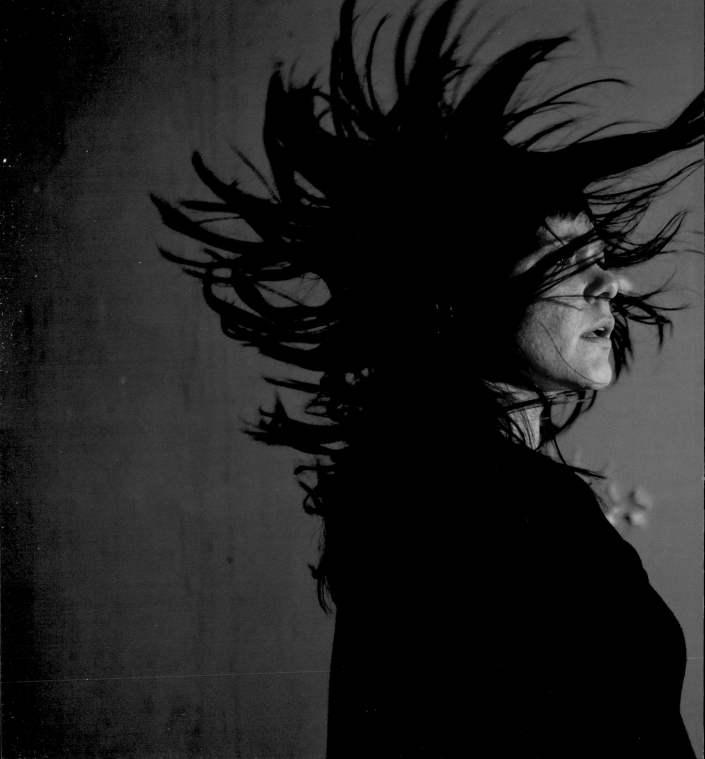

Maria Elena Bilbao Herrera

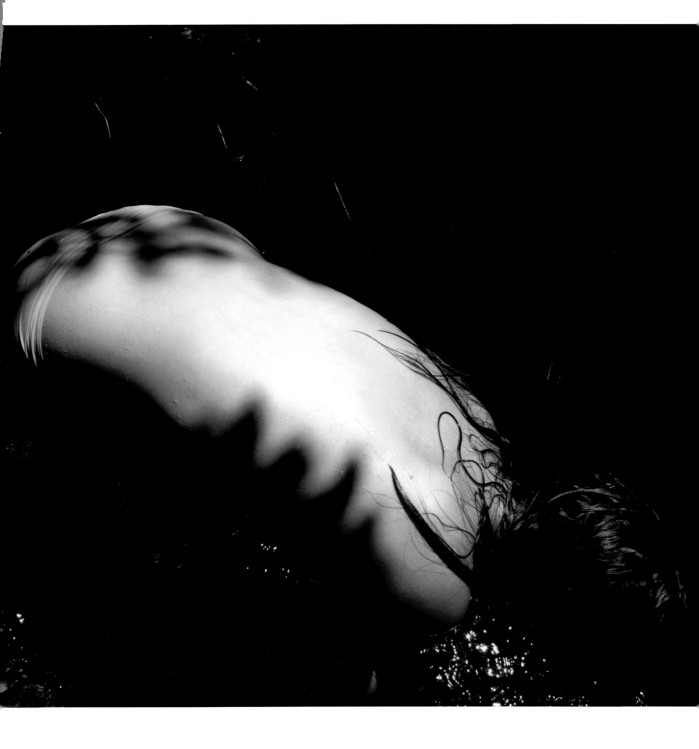

Teresa LoJacono

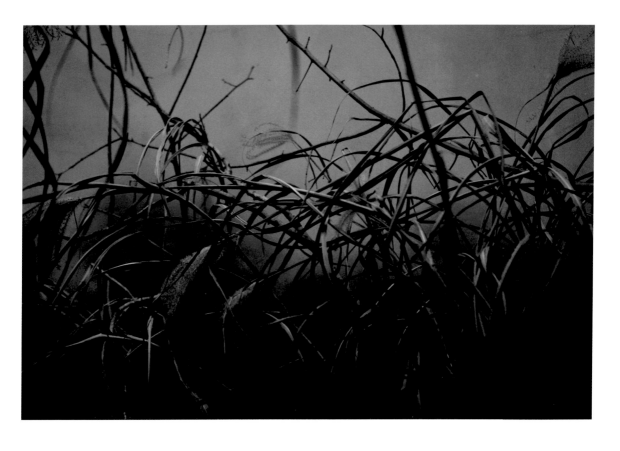

O R D E R / D I S O R D E R

What is order by the mind and hand of Man other than our shared illusion that we have control and power to create such order, systems, laws, rules, justice, victories?

Order is not ours; the needed illusion of order as Man-made is. And so the illusion serves us. Deceives us.

And with it we rule, rise, and fall. Rule, rise, and fall.

The human Intellect, from its peculiar nature, easily supposes a greater order and equality in things than it actually finds; and, while there are many things in Nature unique, and quite irregular, still it feigns parallels, correspondences, and relations that have no existence. Hence that fiction, that among the heavenly bodies all motion takes place by perfect circles.

Francis Bacon, *Novum Organum*, 1620, L:XIV

Helle Harnisch

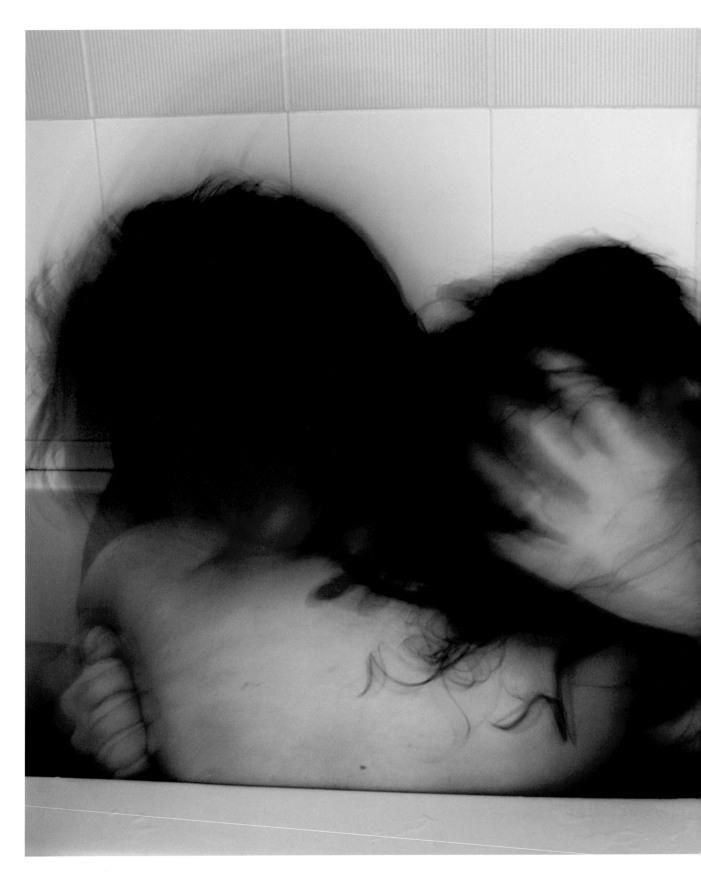

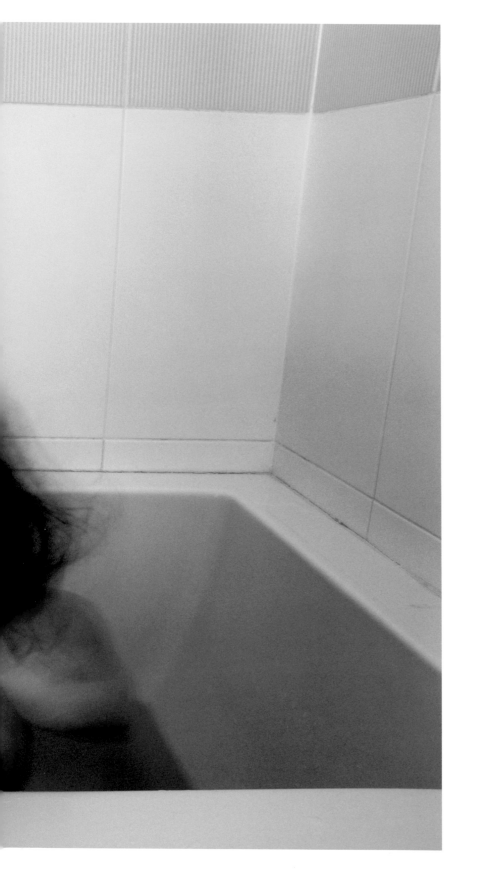

Laura Lee Sabolich

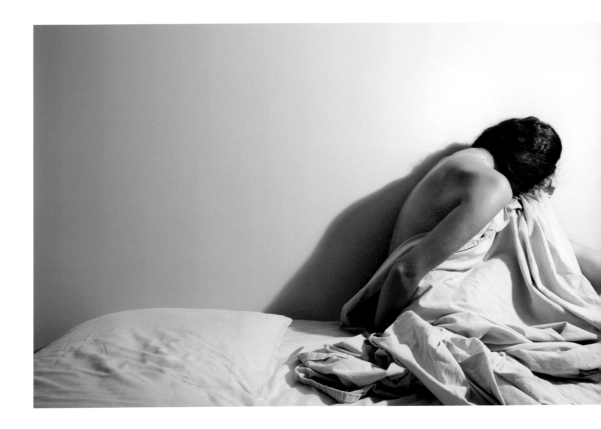

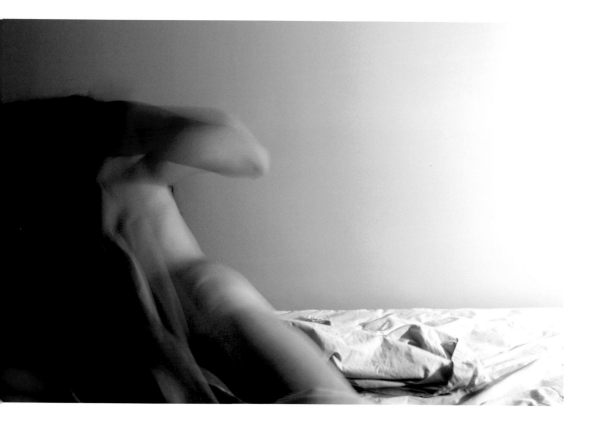

Karen Arango

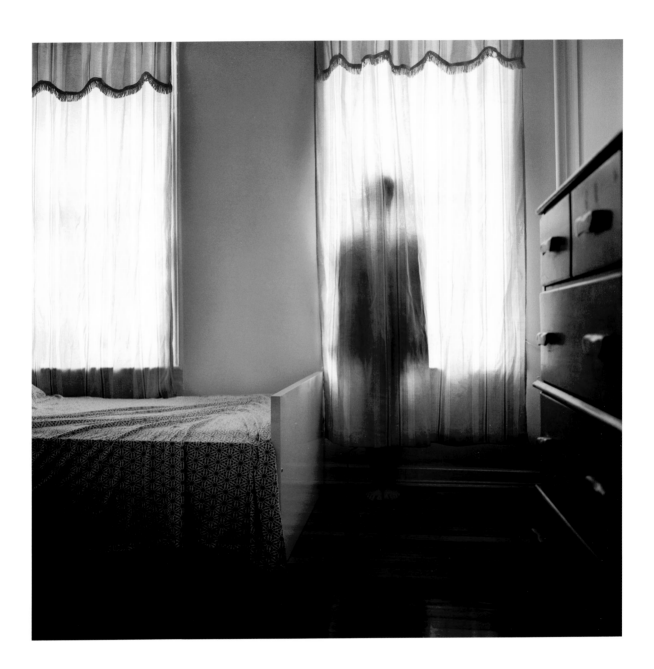

Elisabeth Stiglic

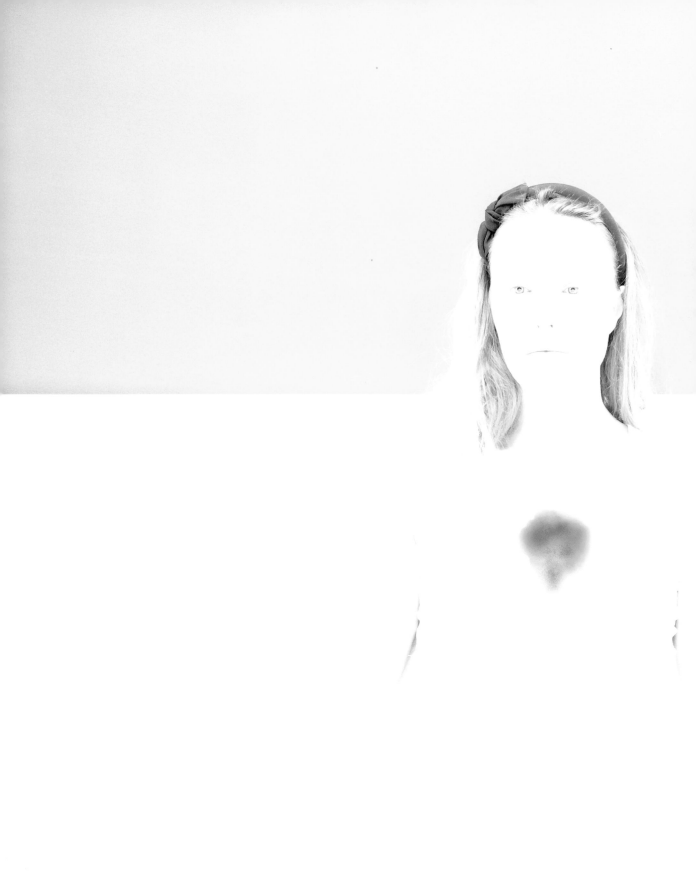

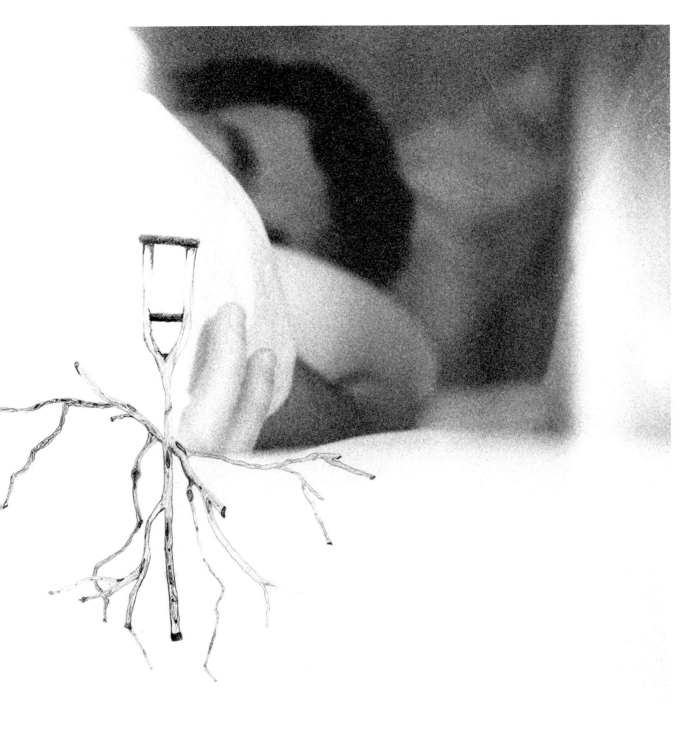

Macarena Rojas Osterling

We fester a strange fascination for volatility and seek beauty in conflict.
We imagine impulse and rage all within the confines of a certain calm.
We claim to be in control, our expression even suggests that,
our actions speak otherwise.

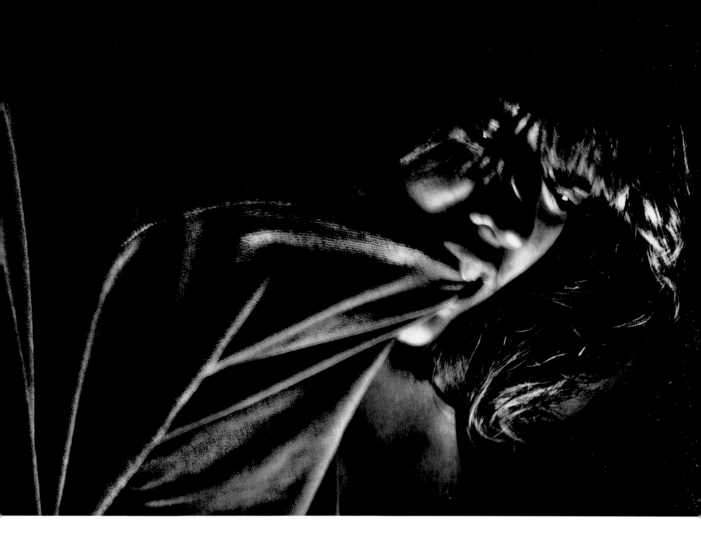

Abhinav Sanghi

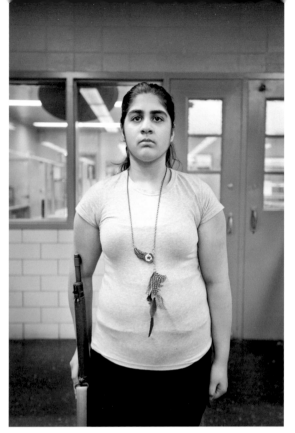
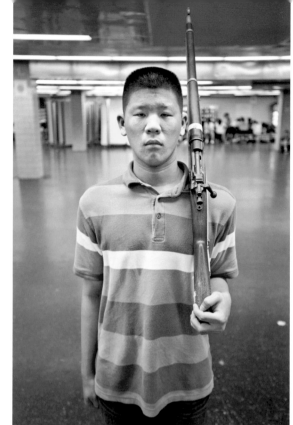
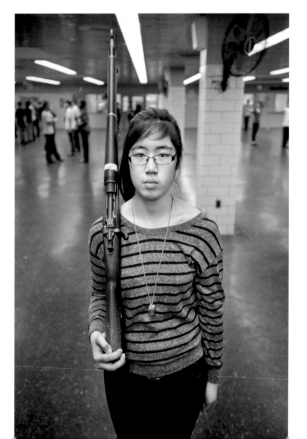
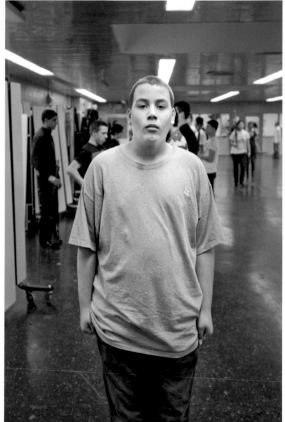

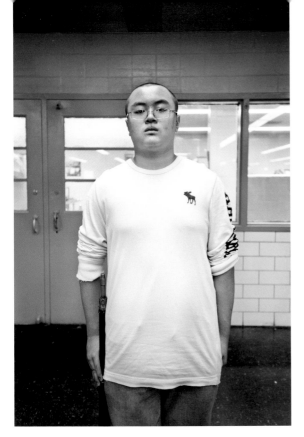

Cadet, what is the Army JROTC creed?

I am an Army Junior ROTC Cadet.

I will always conduct myself to bring credit to my family, country, school, and the Corps of Cadets.

I am loyal and patriotic. I am the future of the United States of America.

I do not lie, cheat, or steal and will always be accountable for my actions and deeds.

I will always practice good citizenship and patriotism. I will work hard to improve my mind and strengthen my body.

I will seek the mantel of leadership and stand prepared to uphold the Constitution and the American way of life.

May God grant me the strength to always live by this creed.

Cadet, what is the nomenclature of your rifle?

My rifle is a U.S. Garand model M-1, Mark 6, Mod 0, dummy bolt action, air cooled, gas operated, 30-caliber clip fed shoulder weapon; that is 40 inches long and weighs 10 pounds. Its maximum effective range is 600 yards from the prone position.

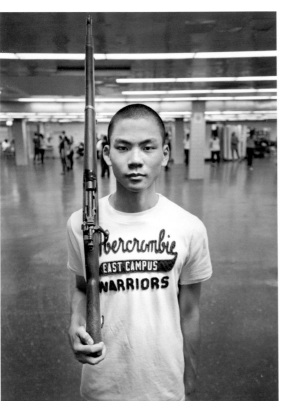

Adrian Jacob Fussell

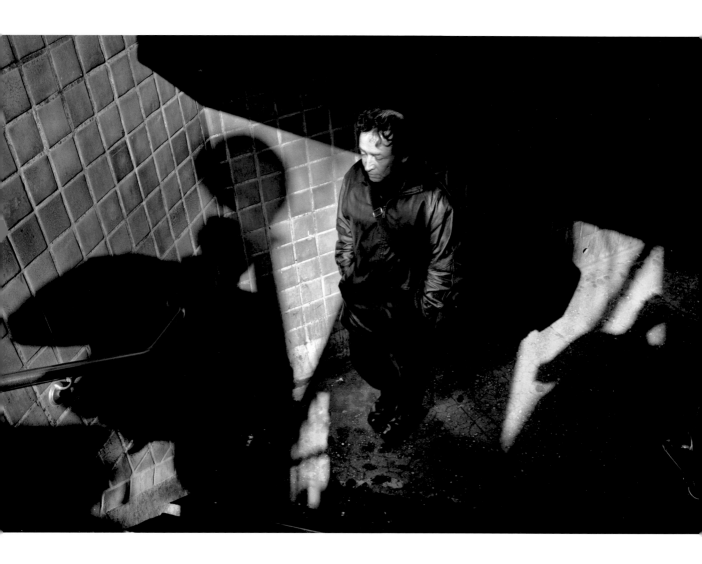

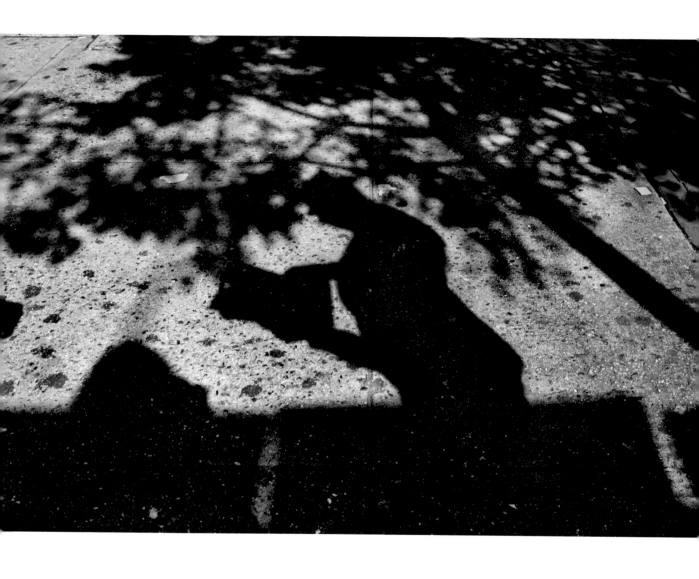

Ruth Prieto Arenas

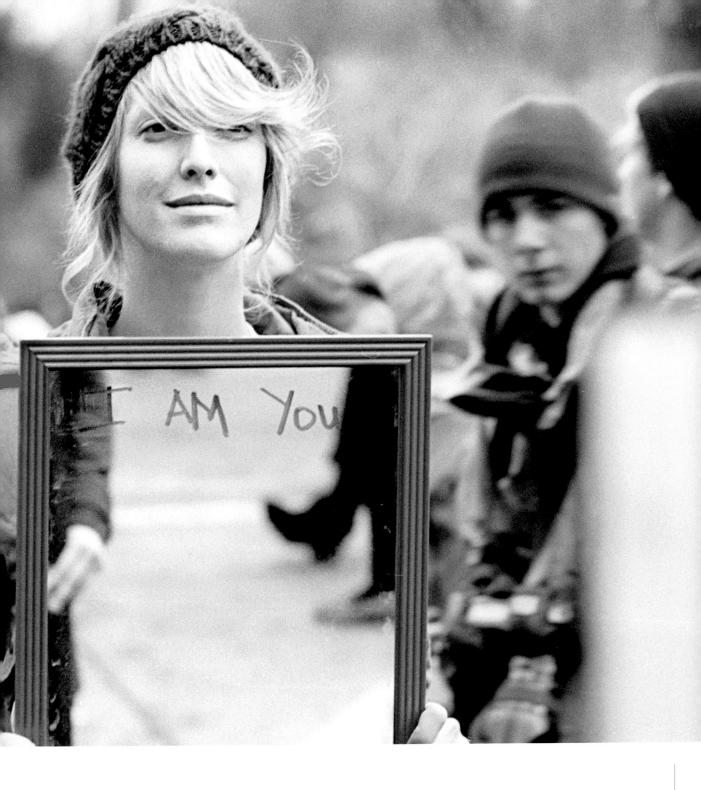

Gabriele Giugni

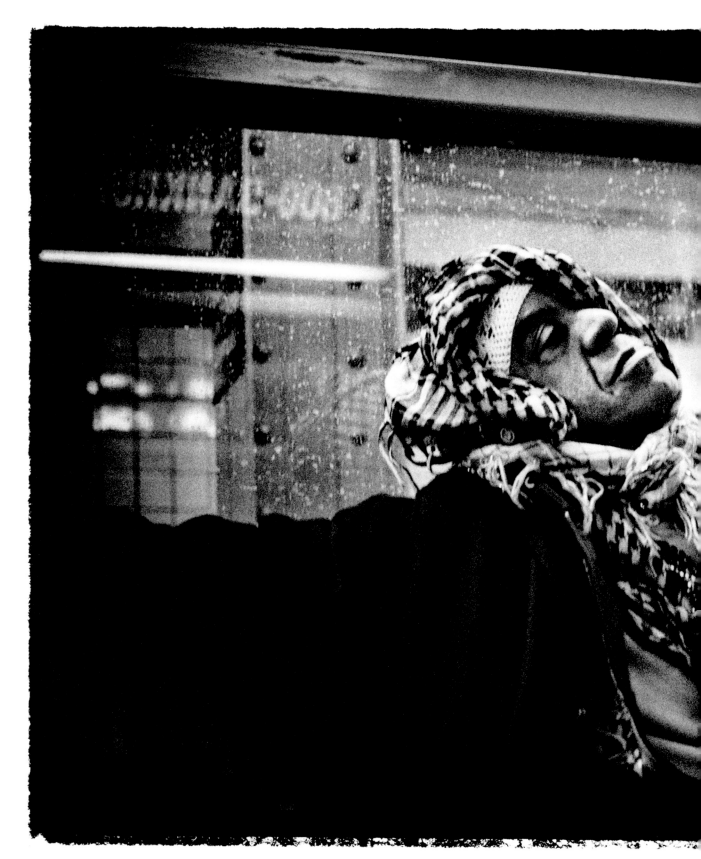

Clement Rouquette

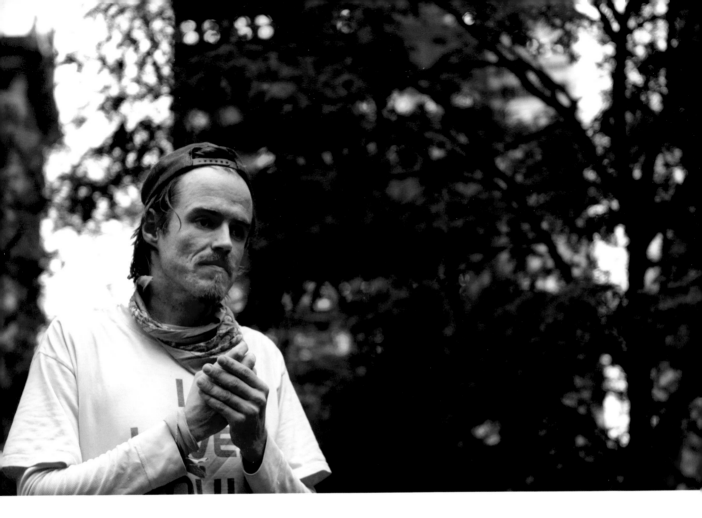

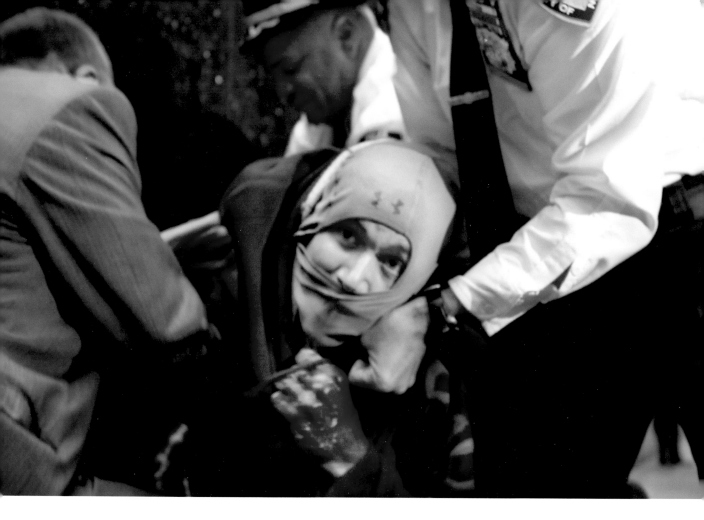

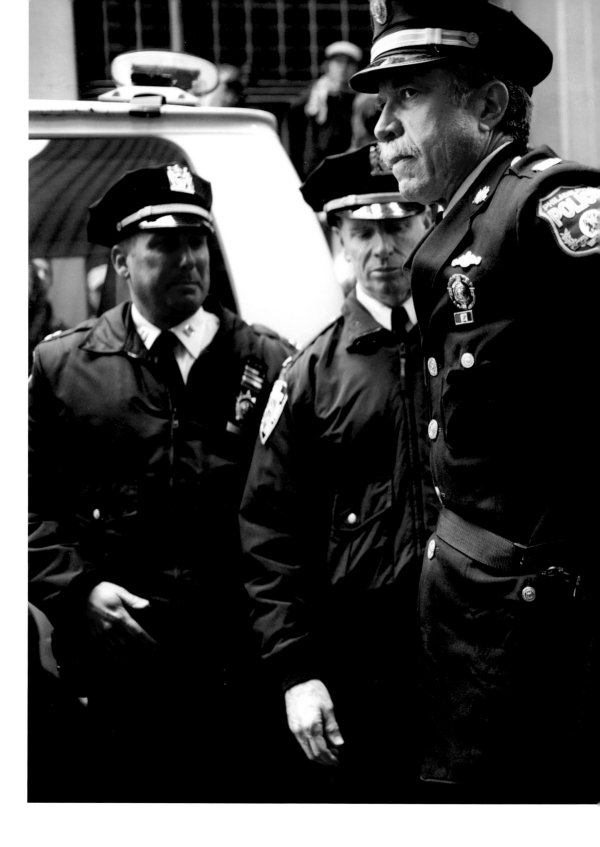

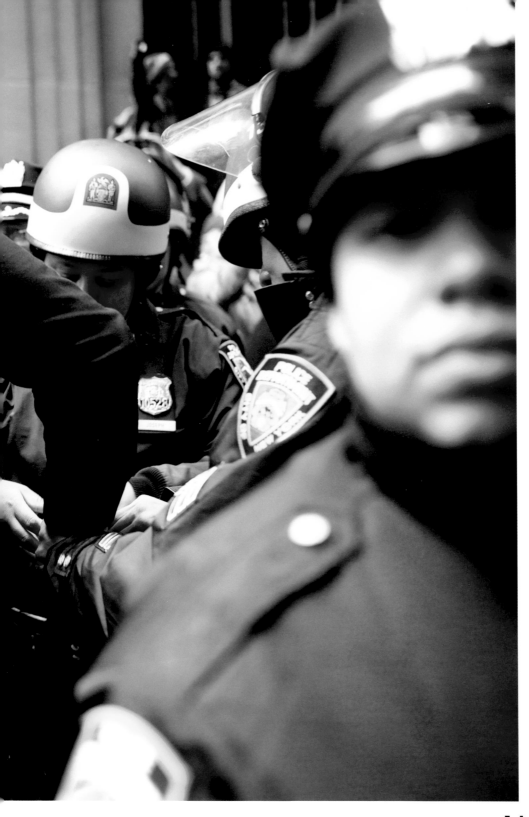

John Anthony Milano

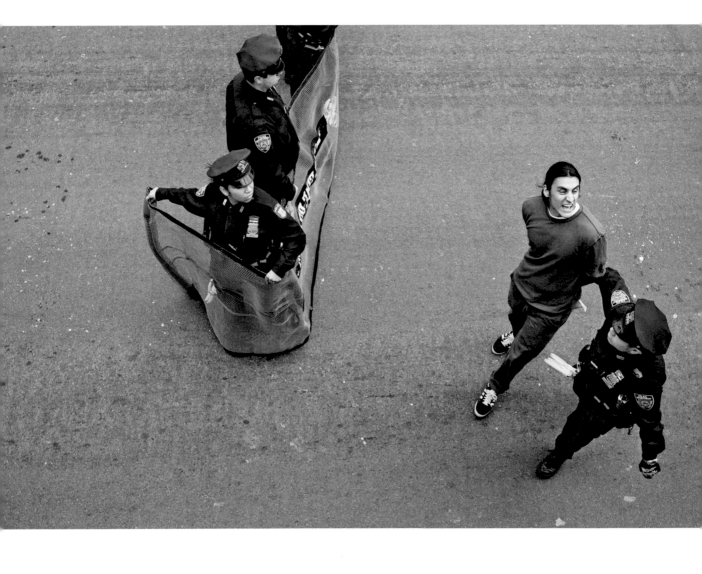

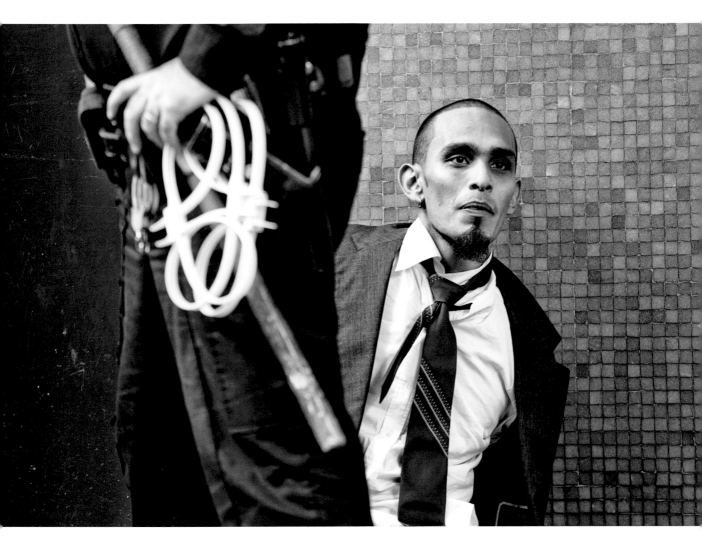

Andre Malerba

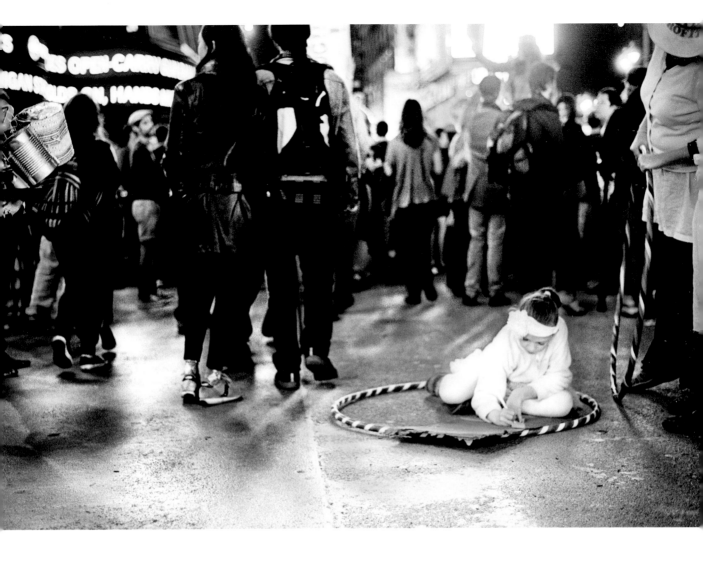

Meredith Rutledge

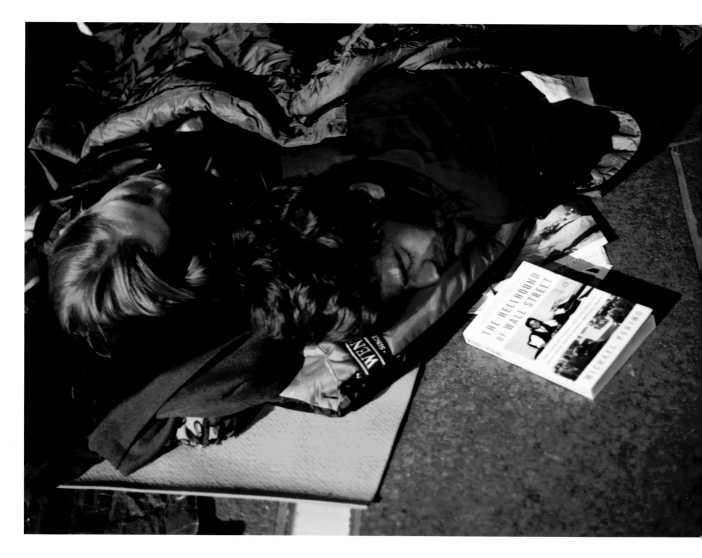

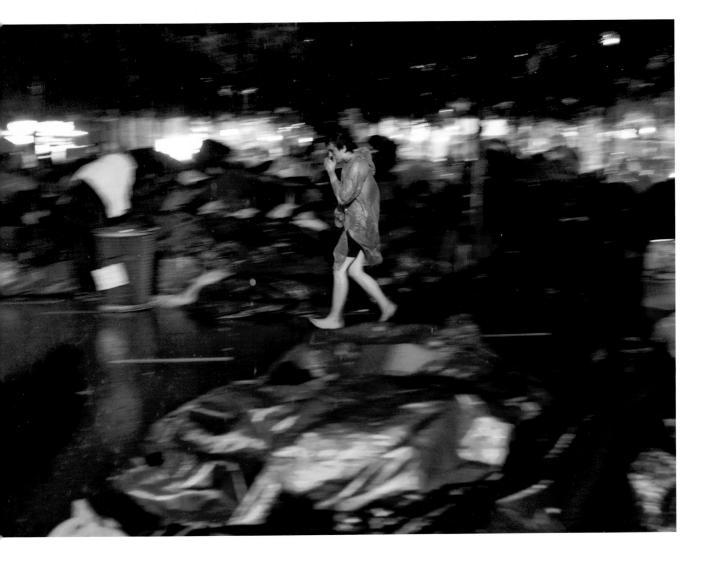

Cory Schwartz

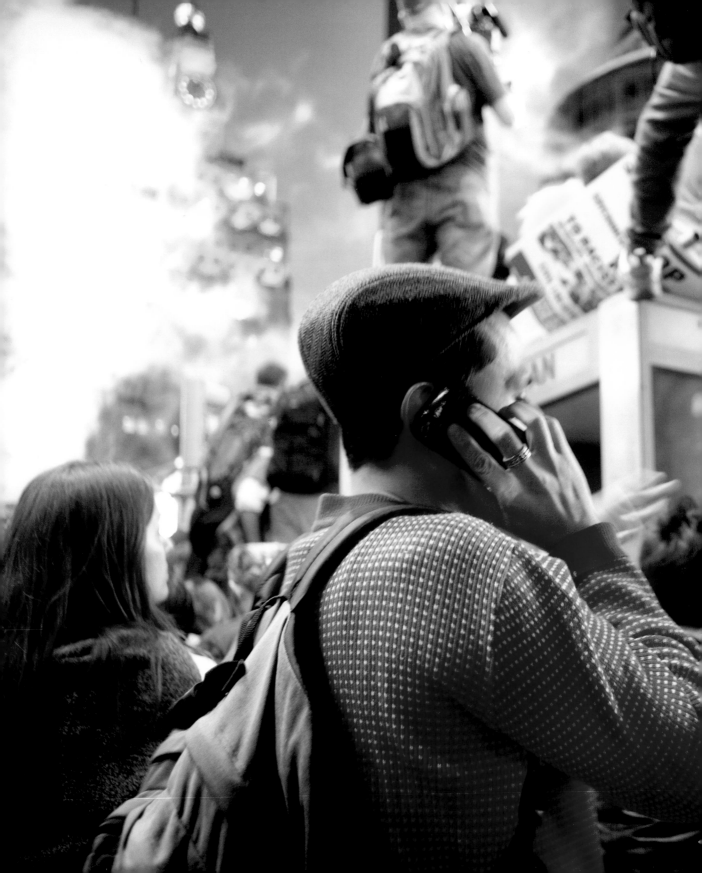

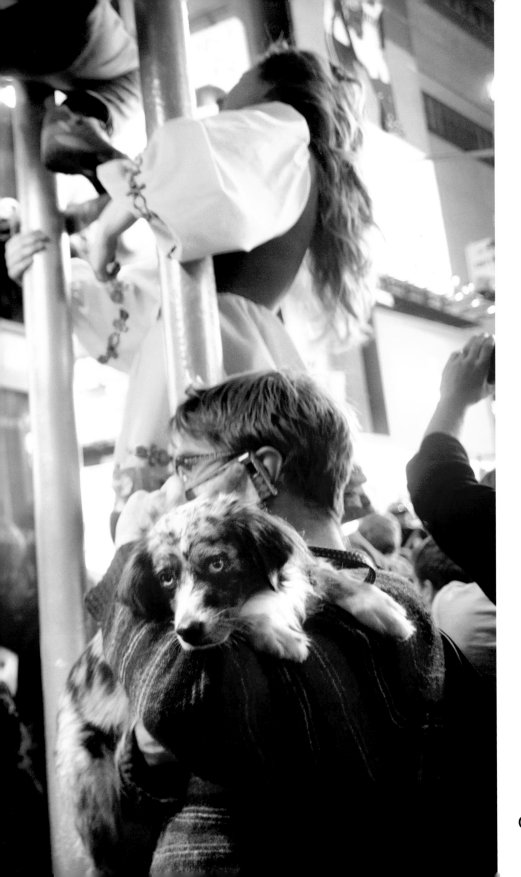

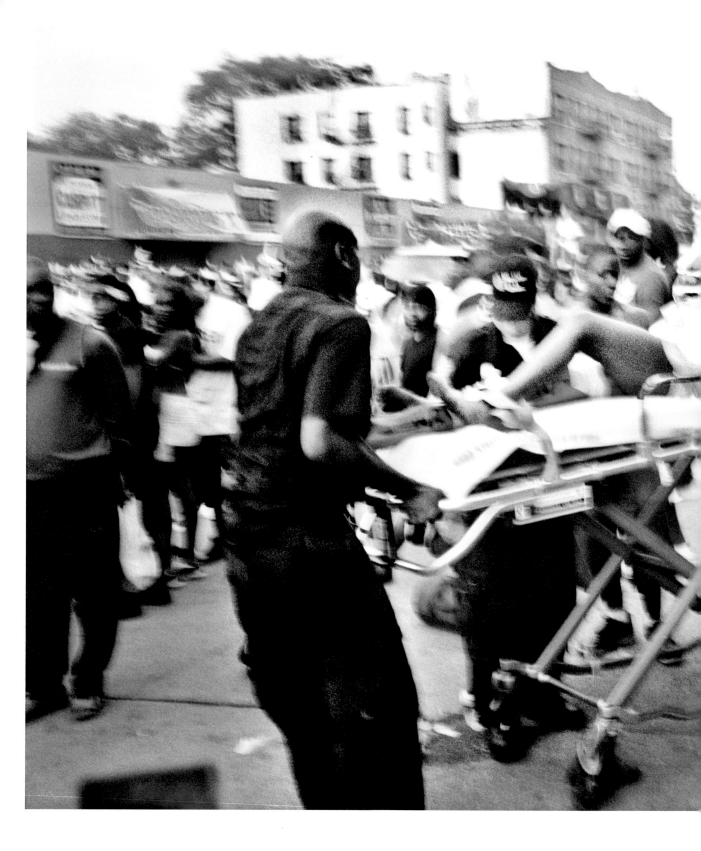

Other parades seem dull after you go to J'ouvert, a pre-dawn celebration of Trinidadian and French origin that takes place in Brooklyn during the early hours before the West Indian Day Parade. The costumed participants, covered in paint, oil, and flour, drinking in the streets and dancing to calypso bands, are sometimes possessed by the wild energy of the whole scene. It's more street-party turned riot than an organized parade. Shootings aren't uncommon but the possibility of sudden violence adds an authentic grit to the event that's hard to find in New York these days.

Daniel Tepper
J'OUVERT ON FLATBUSH, 2011

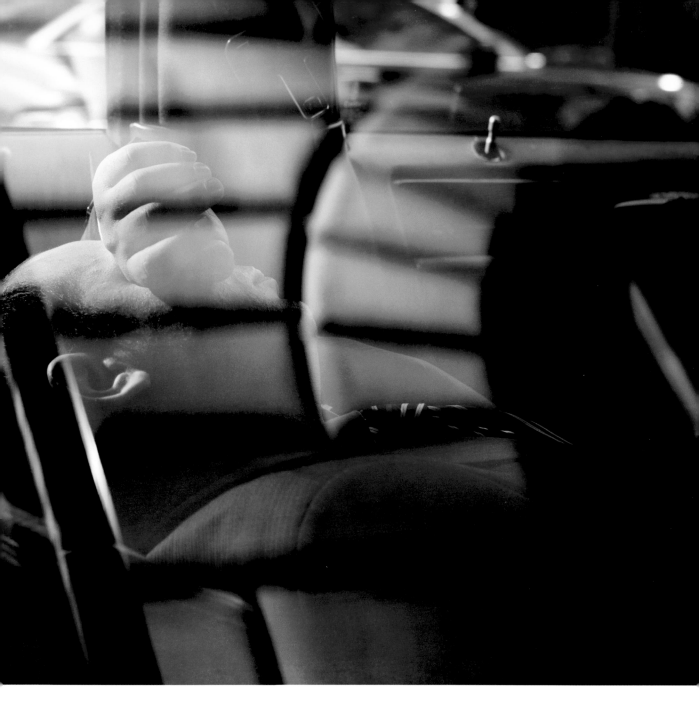

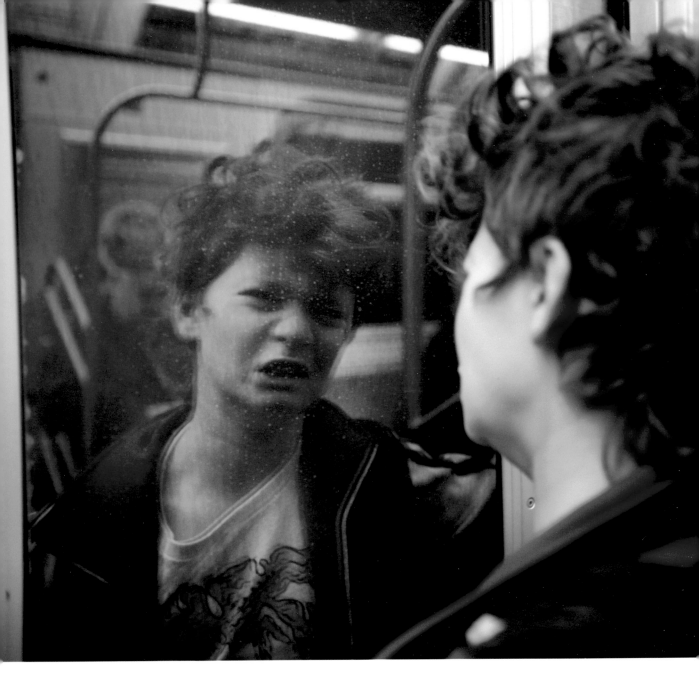

Alessandro Ghirelli

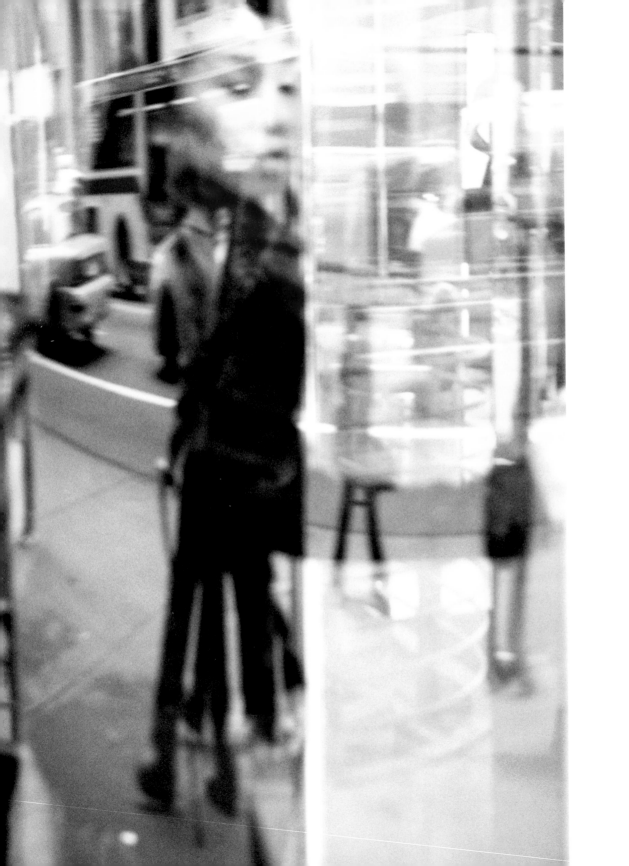

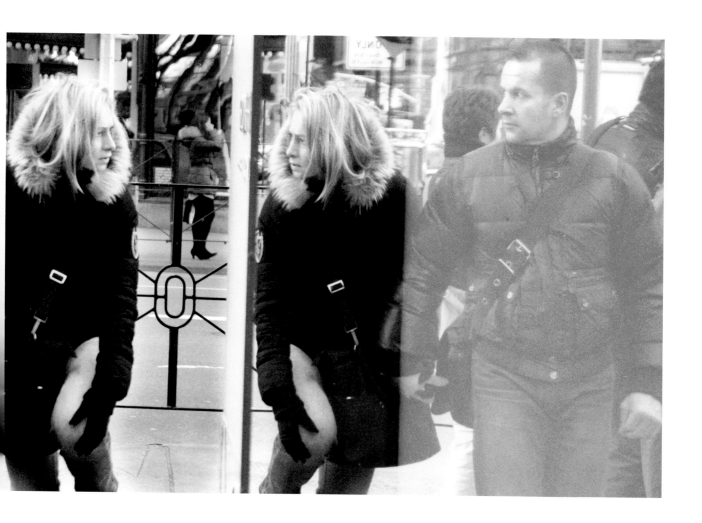

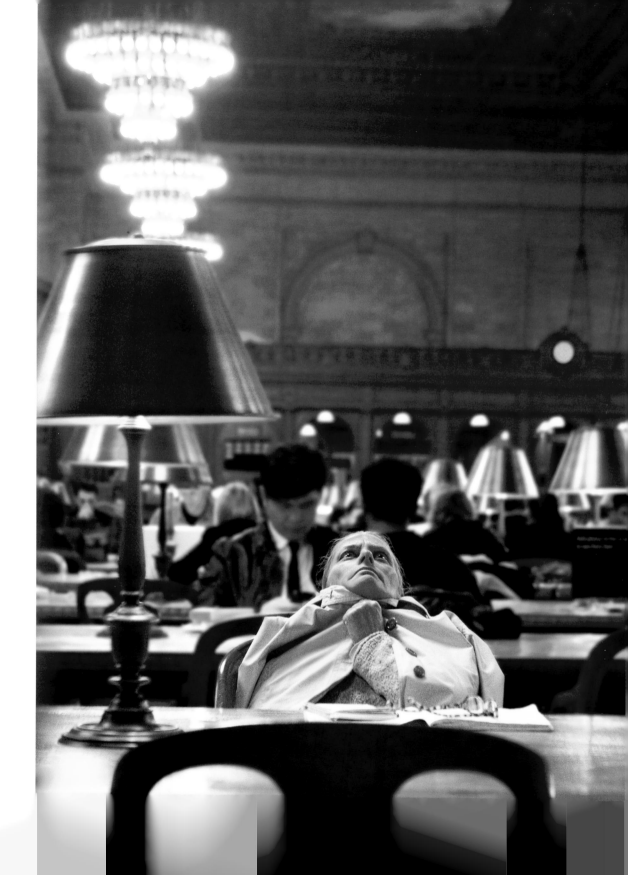

Adhat Campos

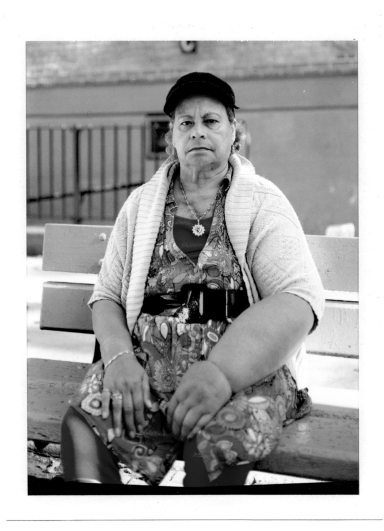

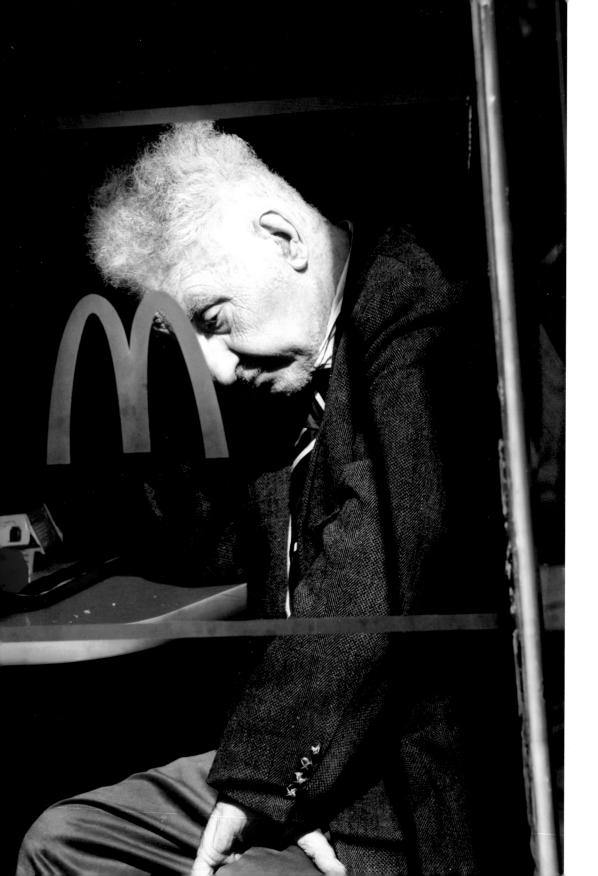

Ramón Ruiz Sampaio

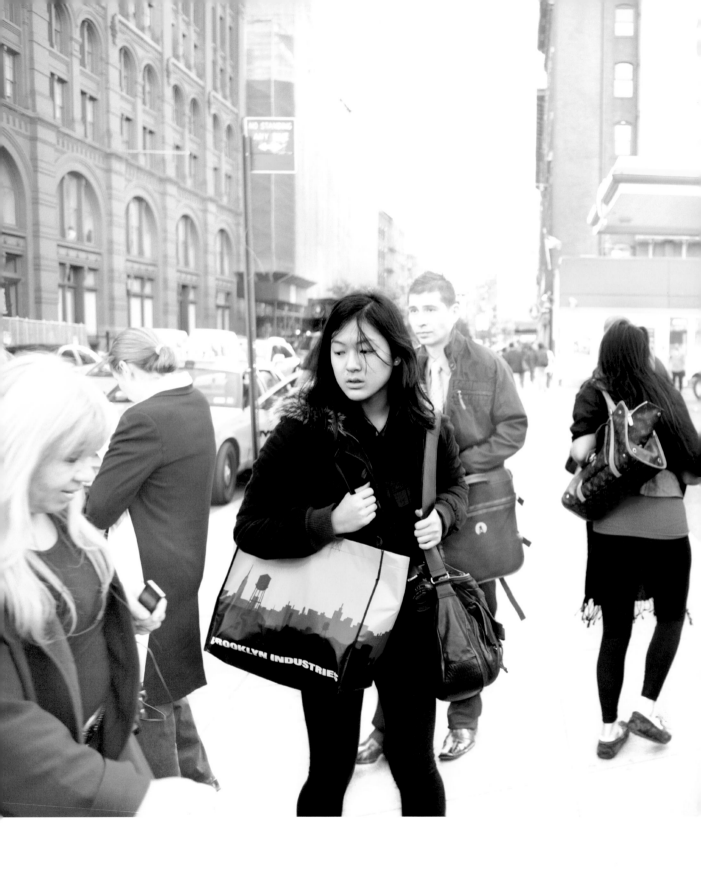

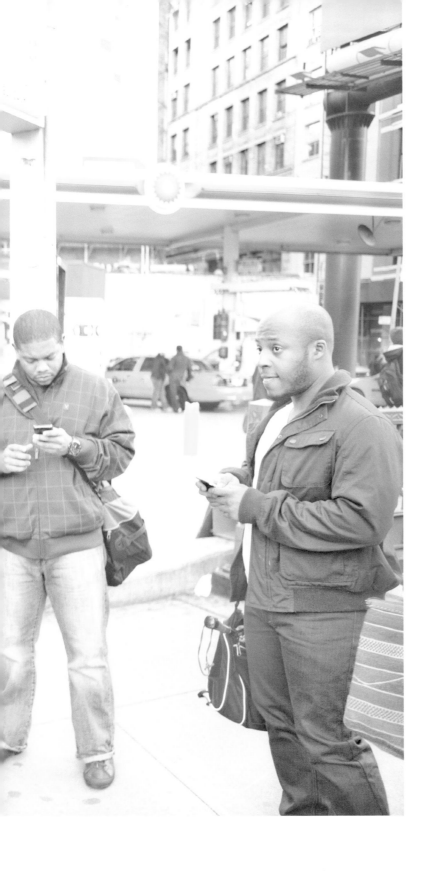

Sina Haghani

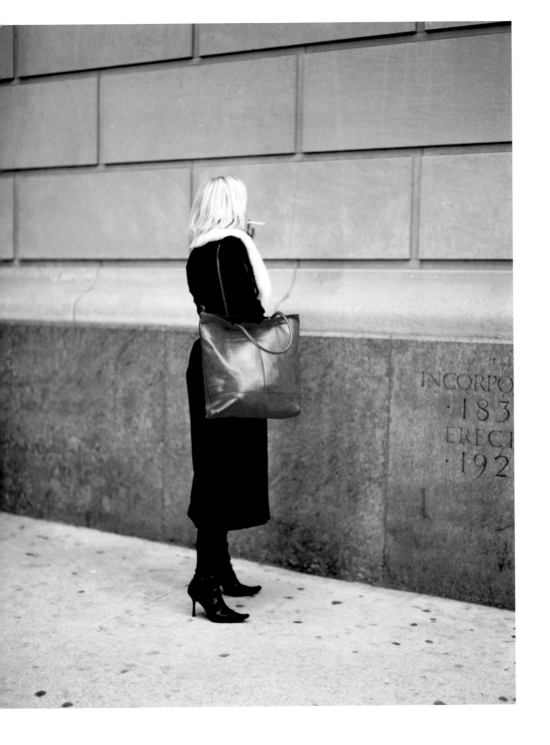

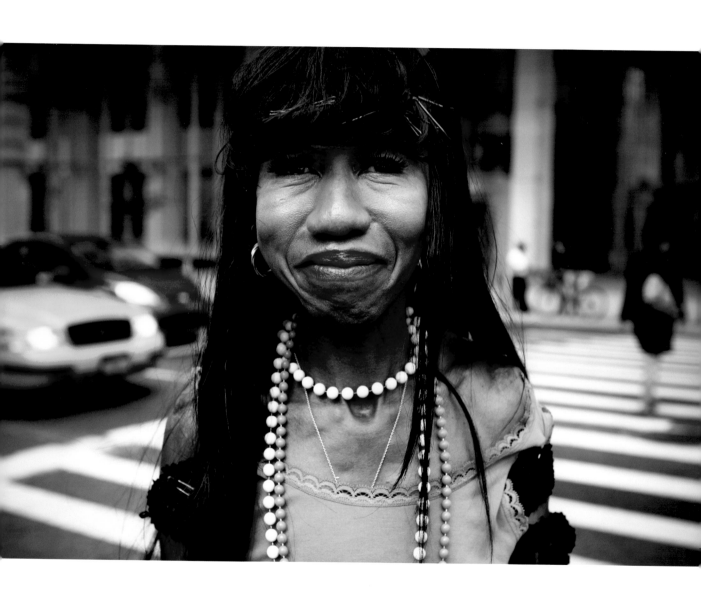

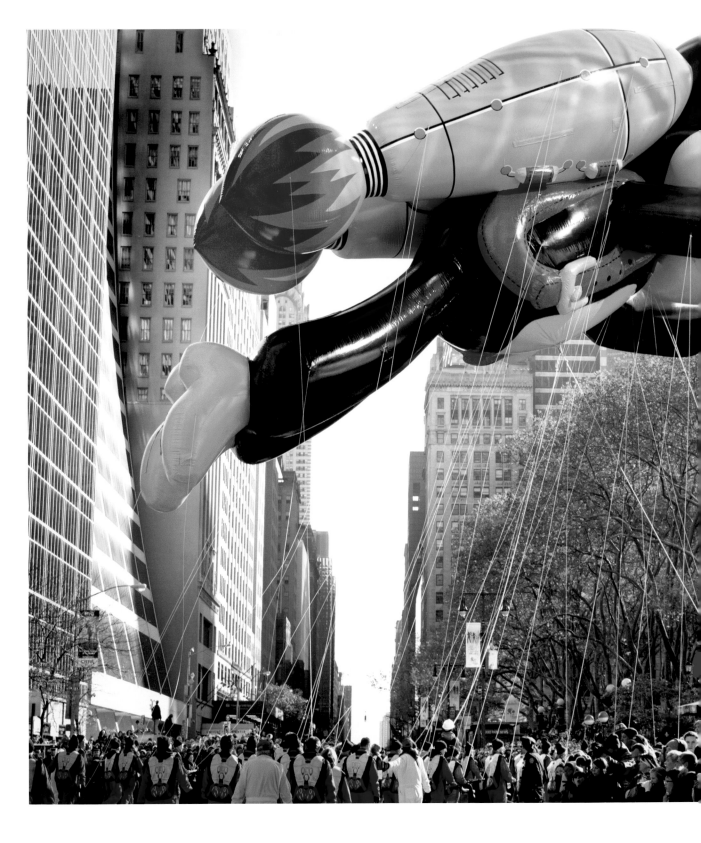

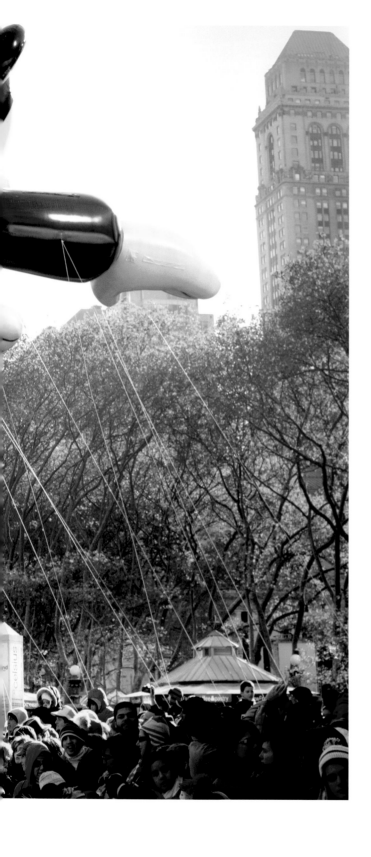

Freya Ingrid Morales Albalá

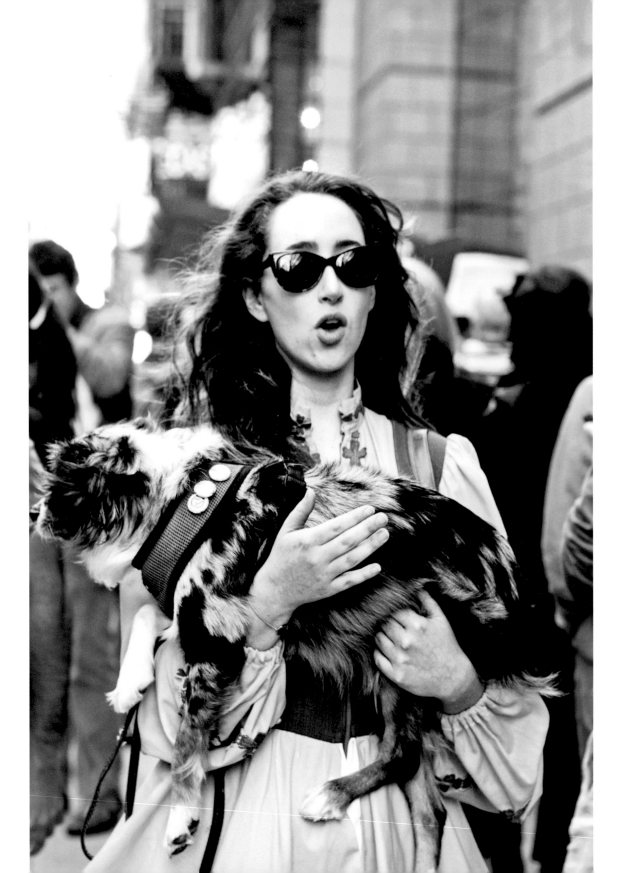

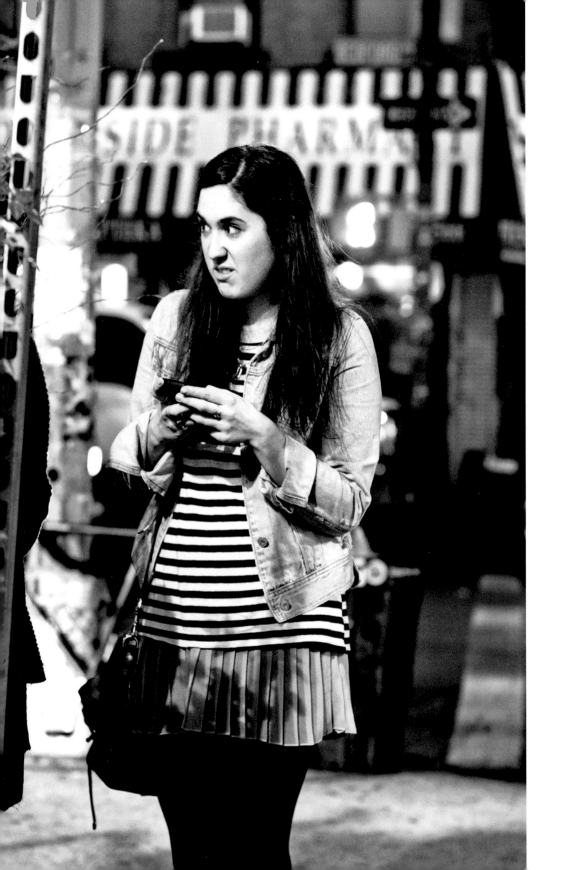

Amina Diaw

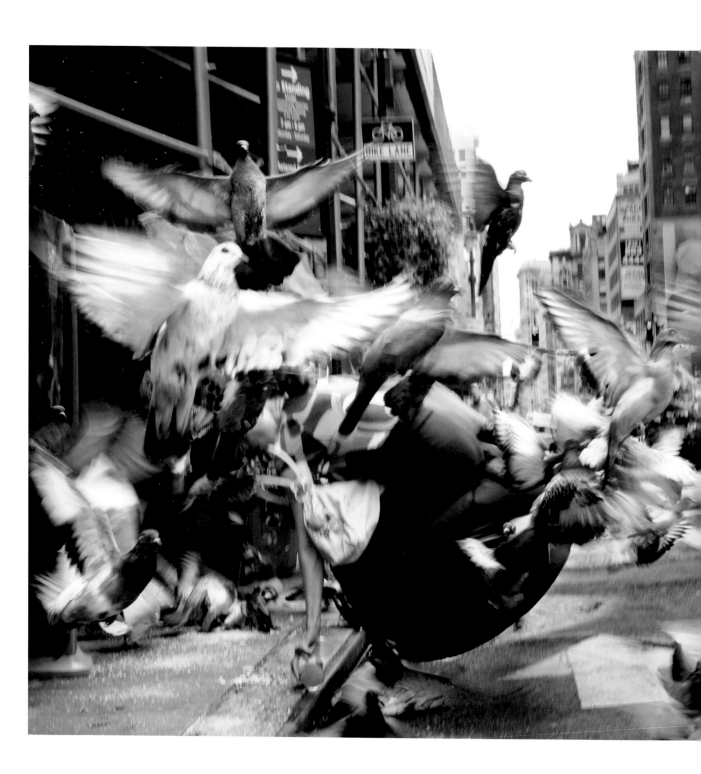

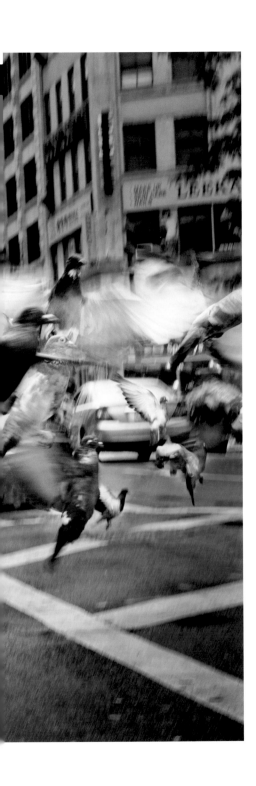

Beth Levendis

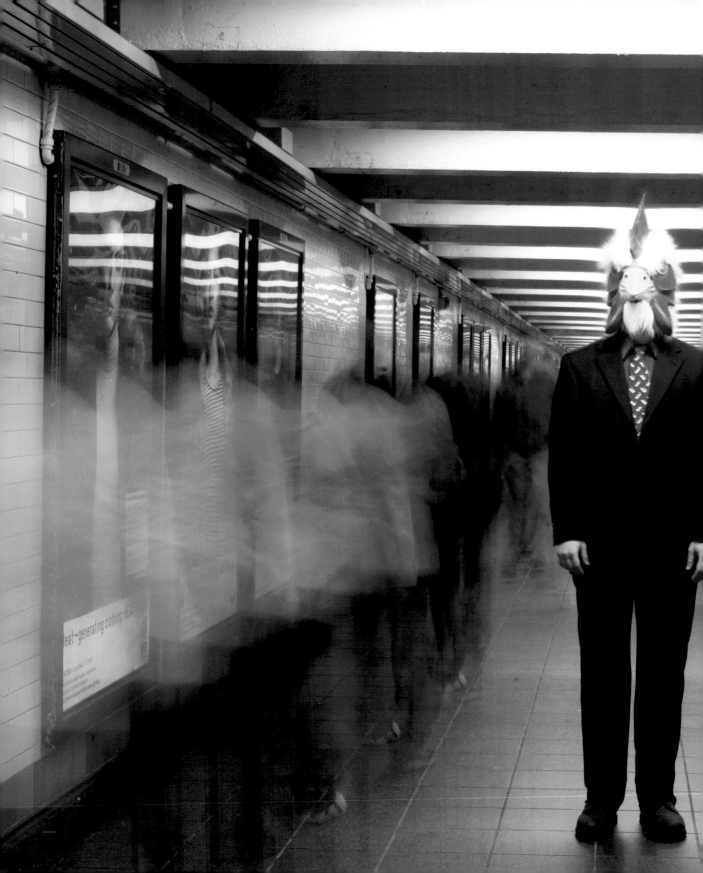

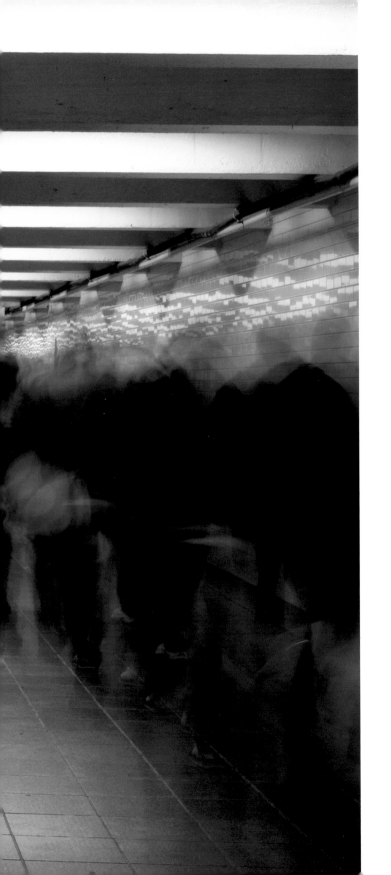

Josh Raab

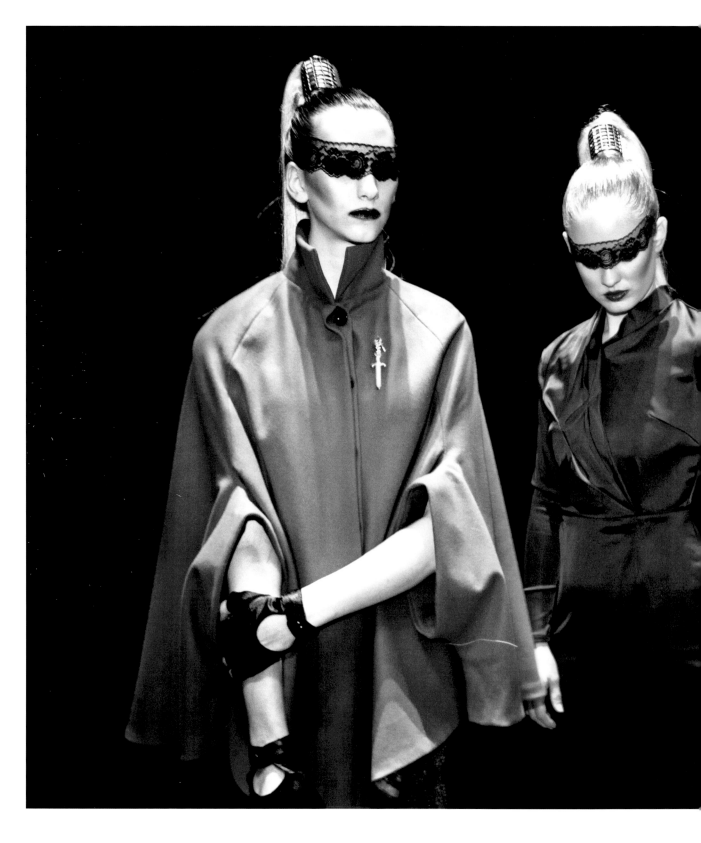

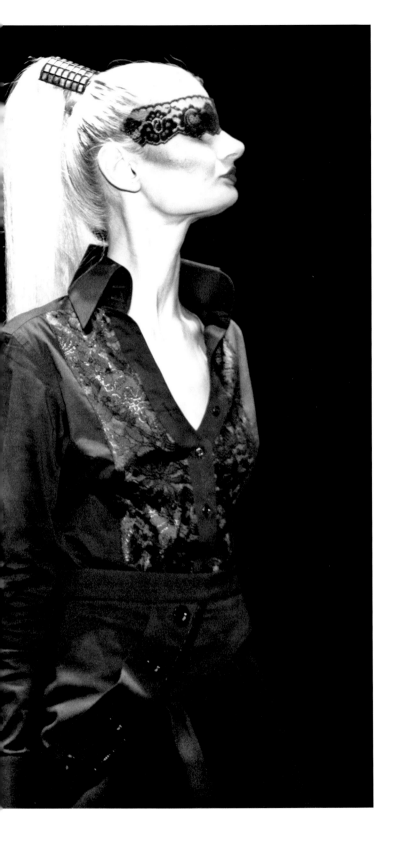

Theresa Balderas

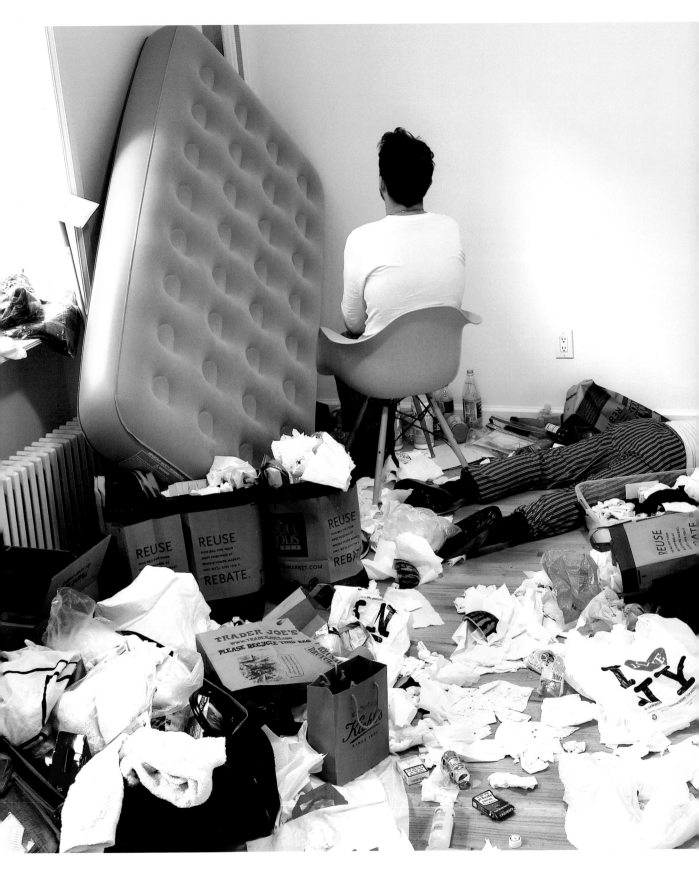

Juan Carlos Munoz-Najar

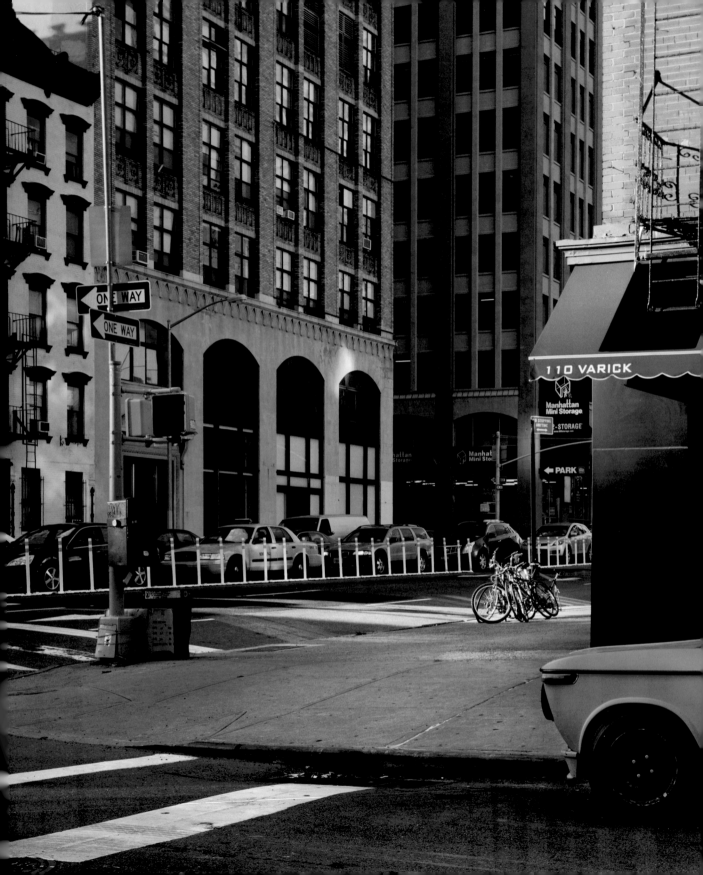

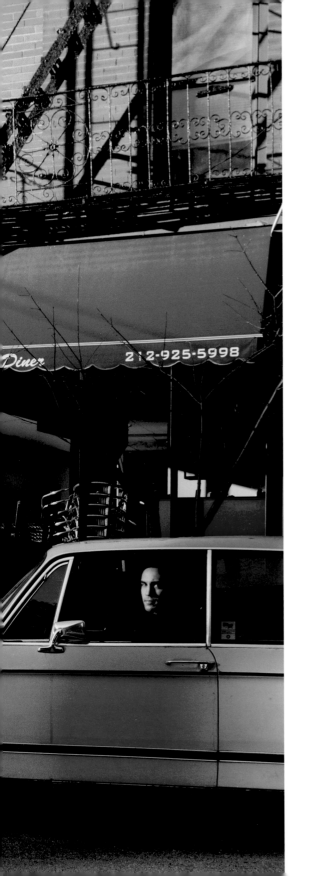

Rodrigo Rosenthal

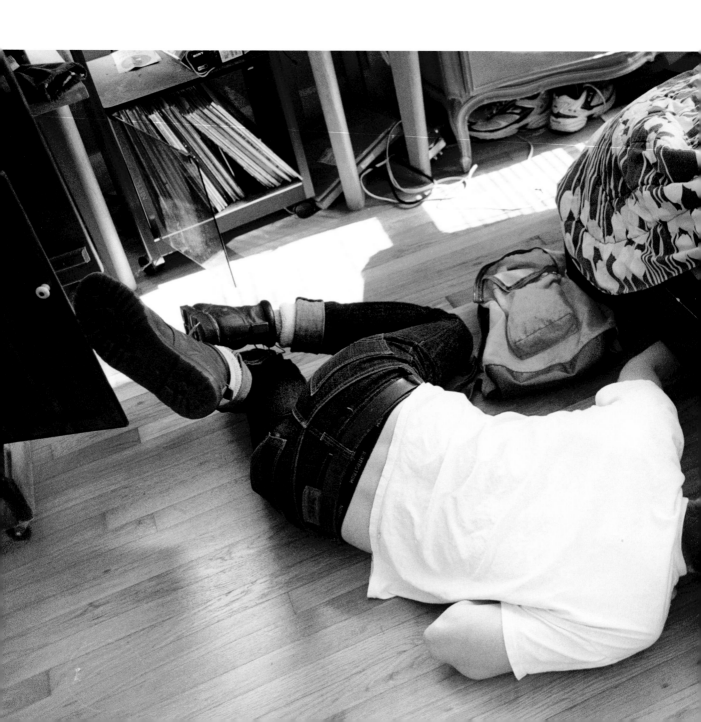

Kristen Farmer

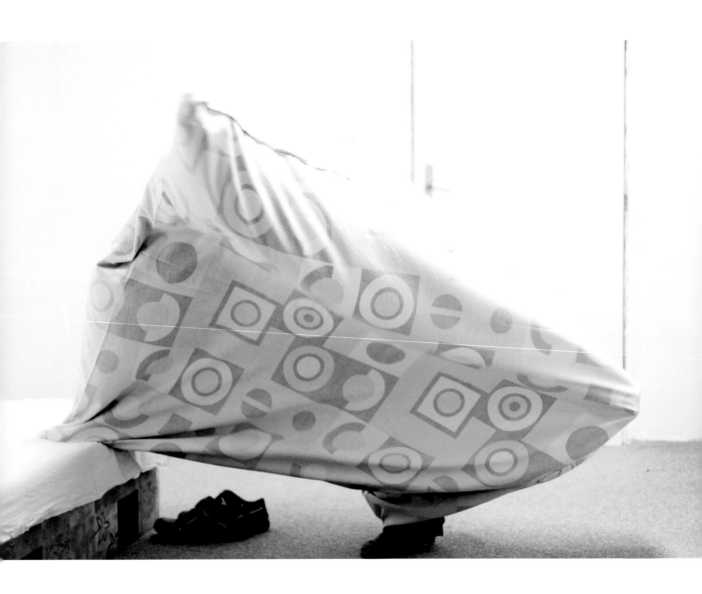

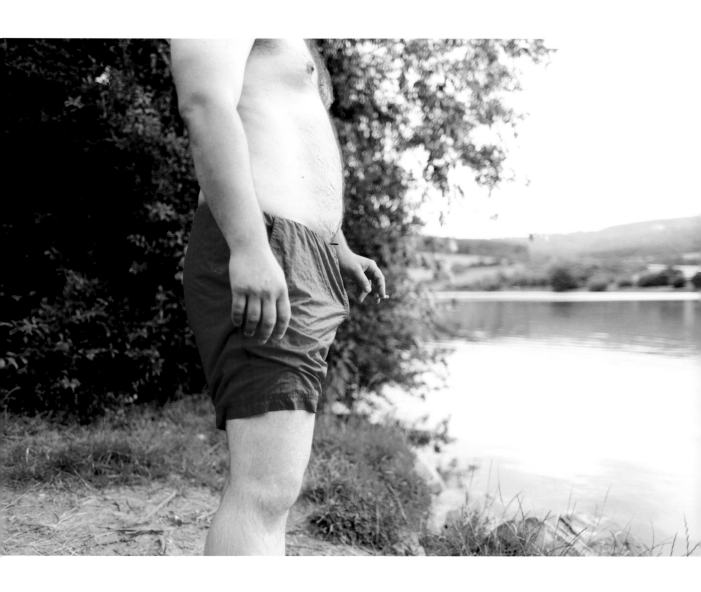

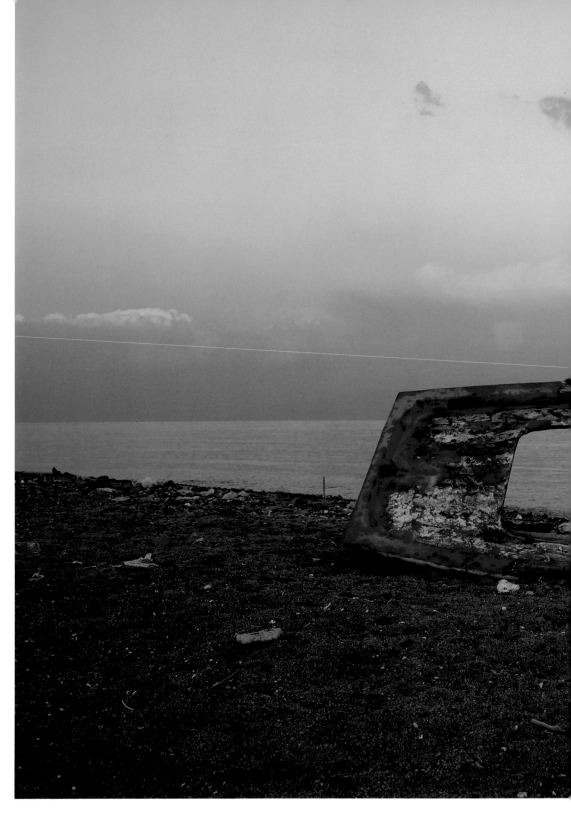

What was once a glass-bottomed boat, now abandoned in disrepair
frames a different view in Dahab, Egypt, Gulf of Aqaba, 2010.

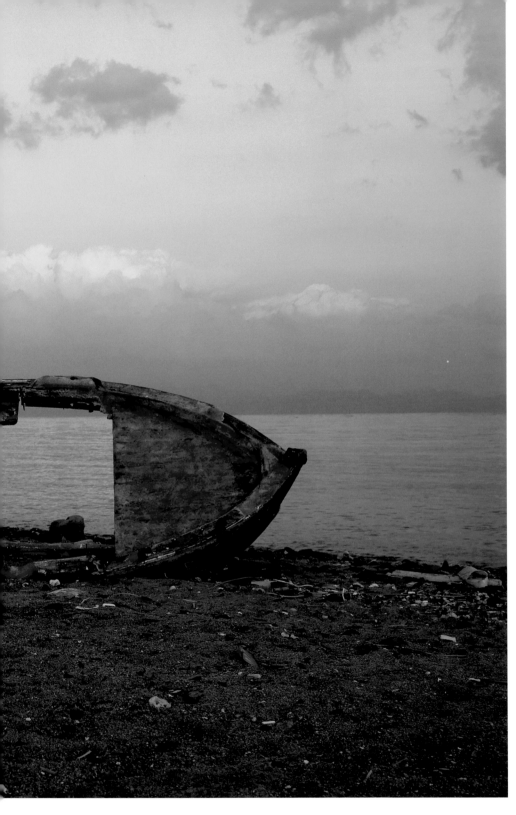

Jorge Alberto Perez

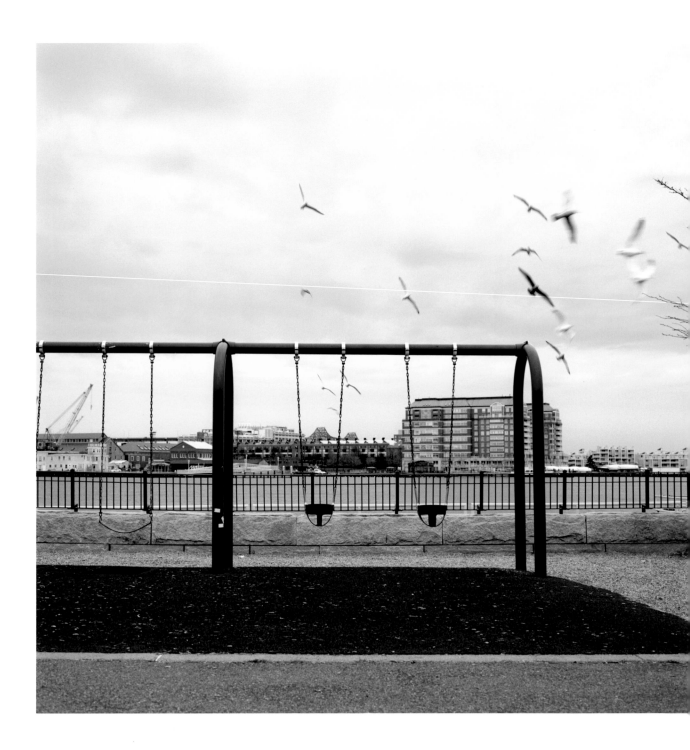

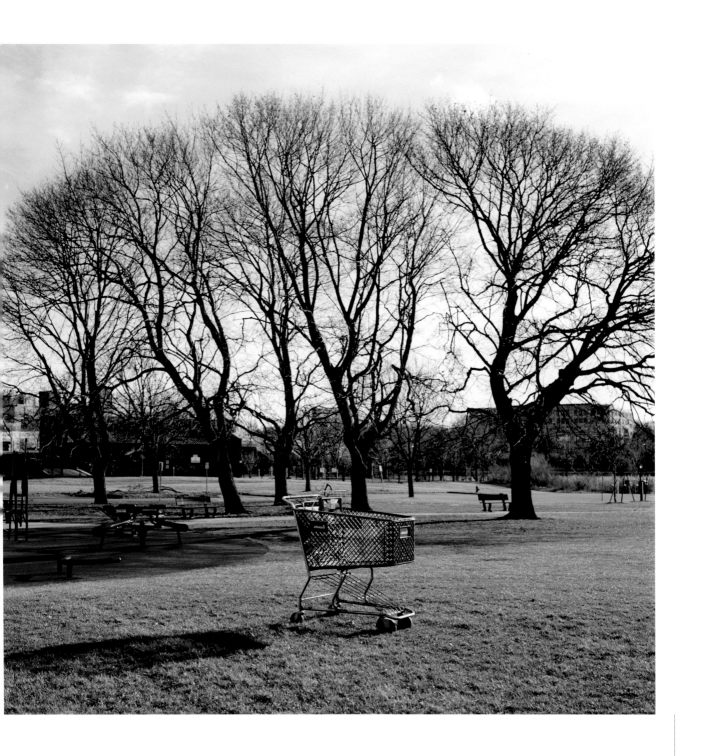

Liang Ni

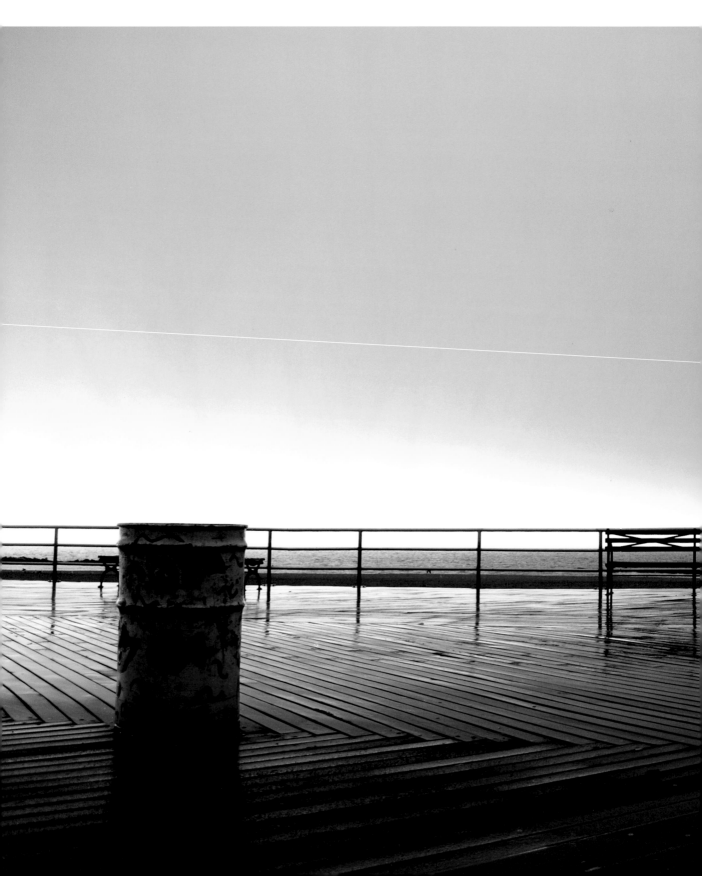

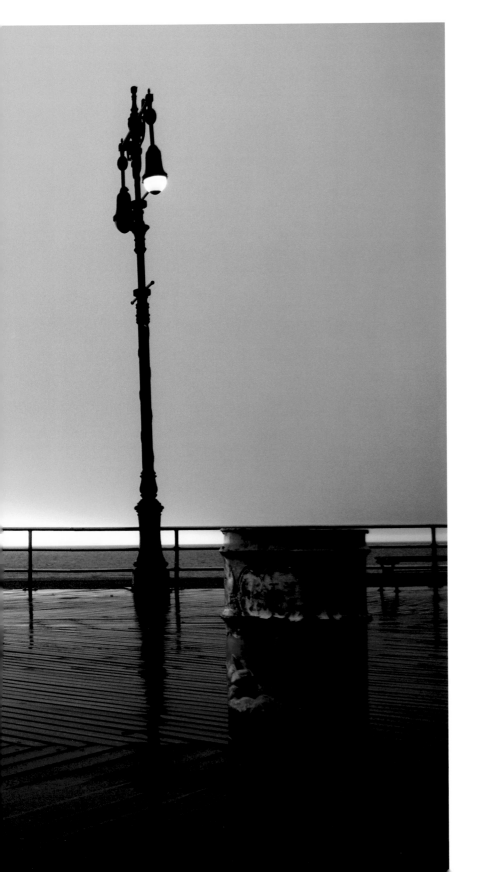

Andrea Manuschevich

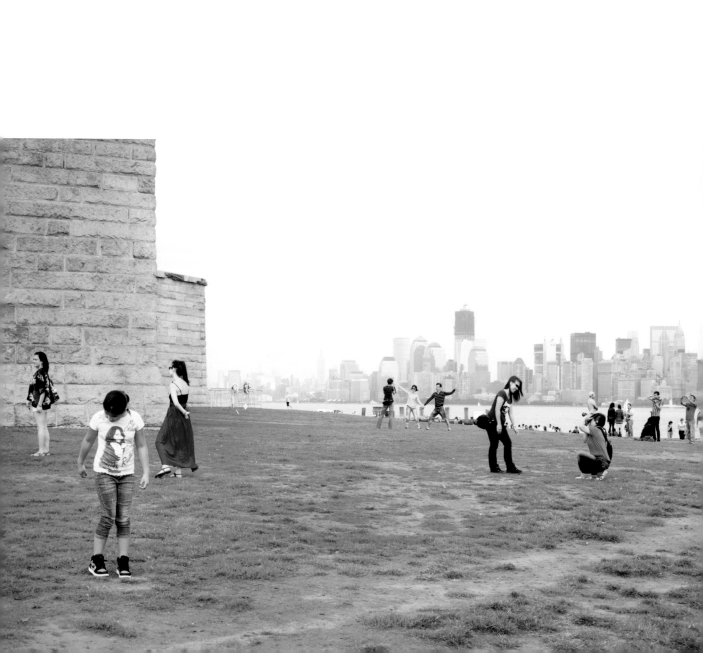

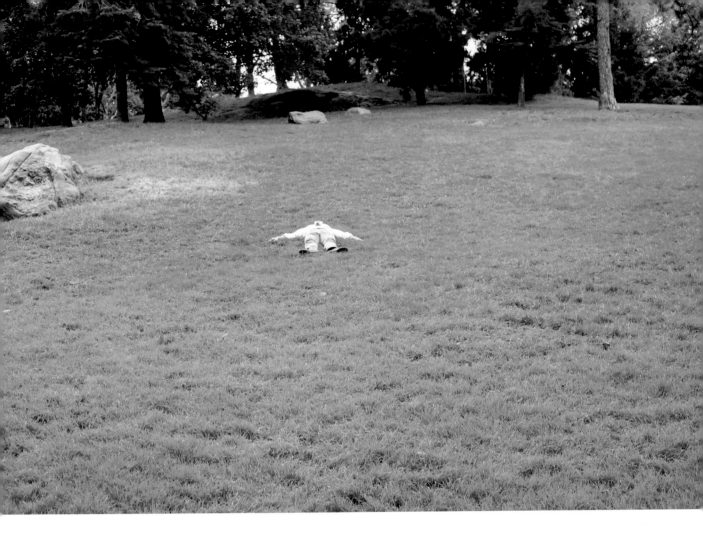

Vittoria Mentasti

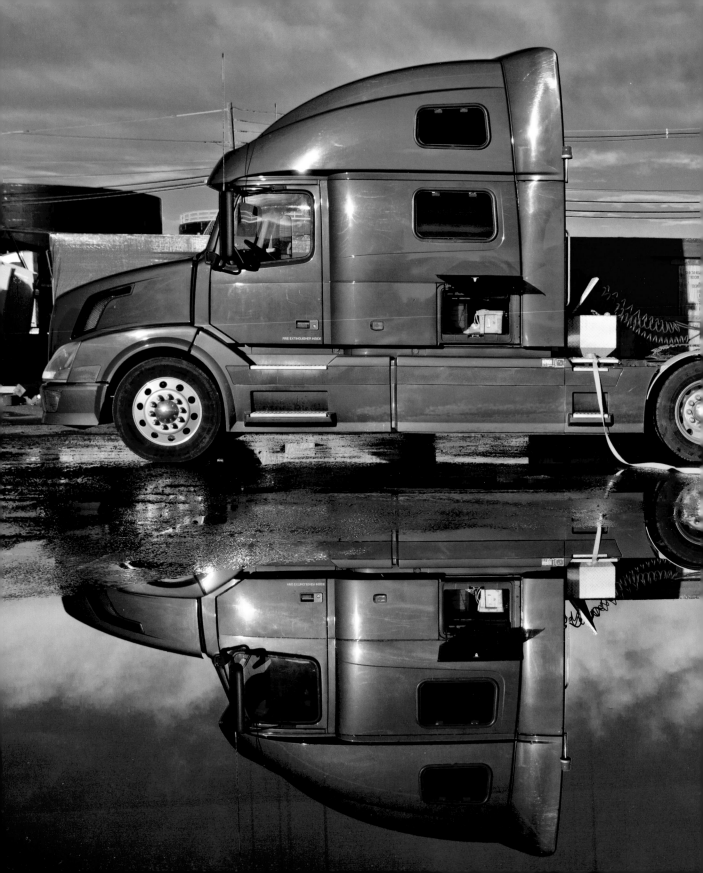

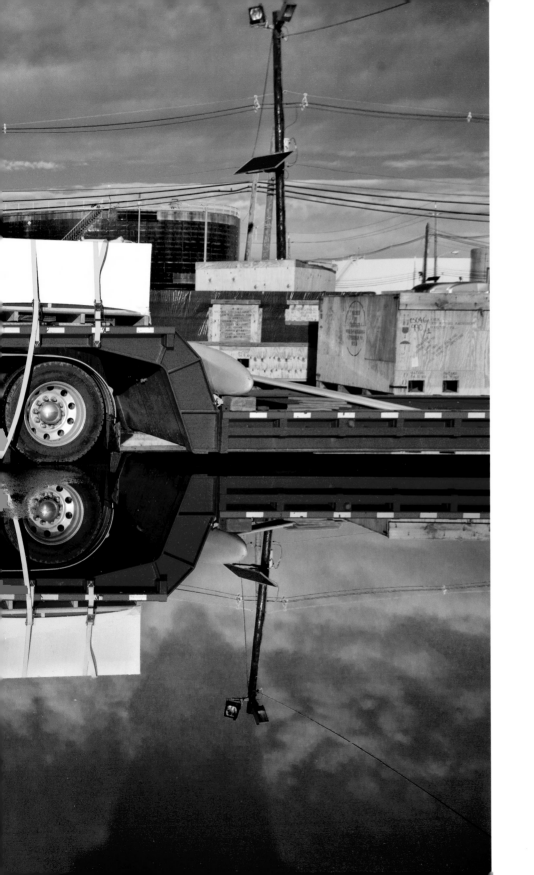

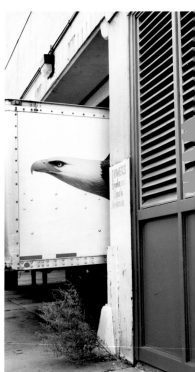

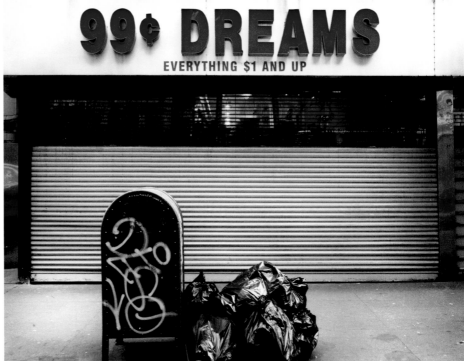

Diana Rangel Lampe

Shayok Mukhopadhyay

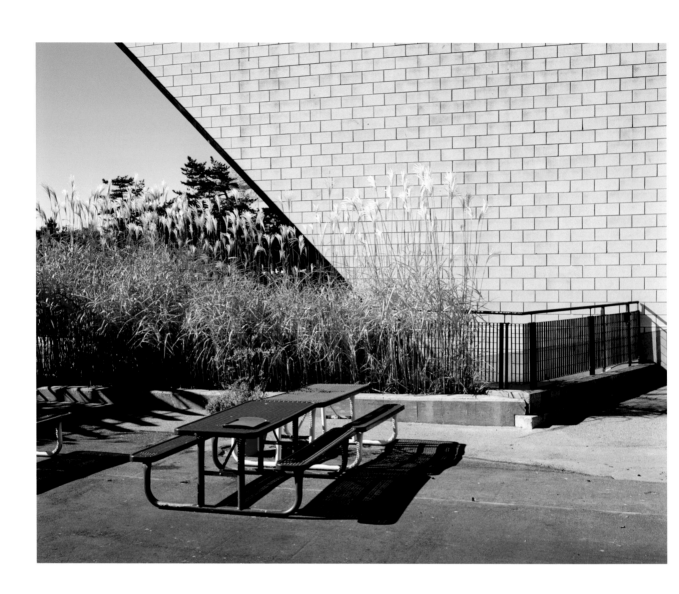

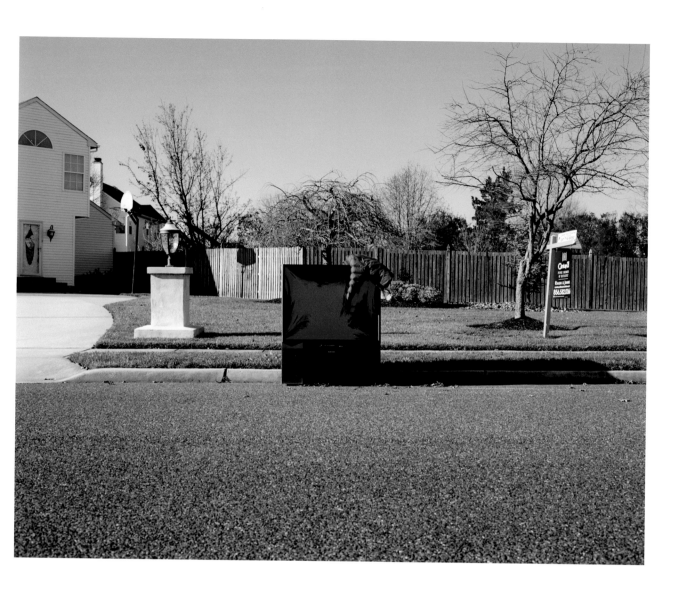

Di Di Lin

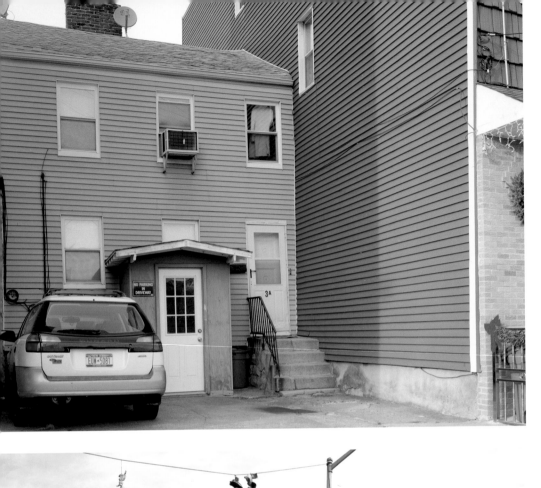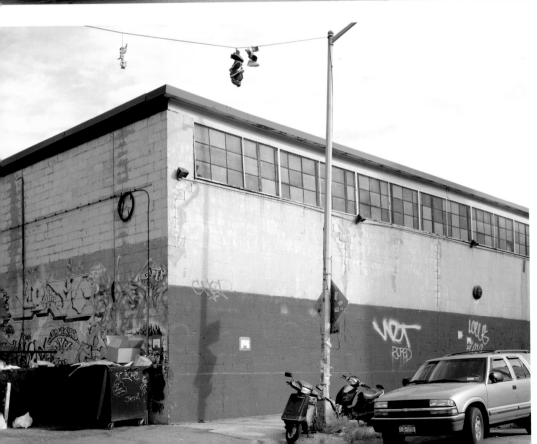

One clear autumn afternoon I was sitting on a bench in the middle of the Piazza Santa Croce in Florence. It was of course not the first time I had seen this square ... The whole world, down to the marble of the buildings and fountains, seemed to me to be convalescent ... Then I had the strange impression I was looking at these things for the first time, and the composition of my picture came to my mind's eye. Now each time I look at that painting I see that moment. Nevertheless the moment is an enigma to me, for it is inexplicable.

Giorgio de Chirico, *Meditations of a Painter*, 1912

Simone Pomposi
AMERICAN FAÇADE

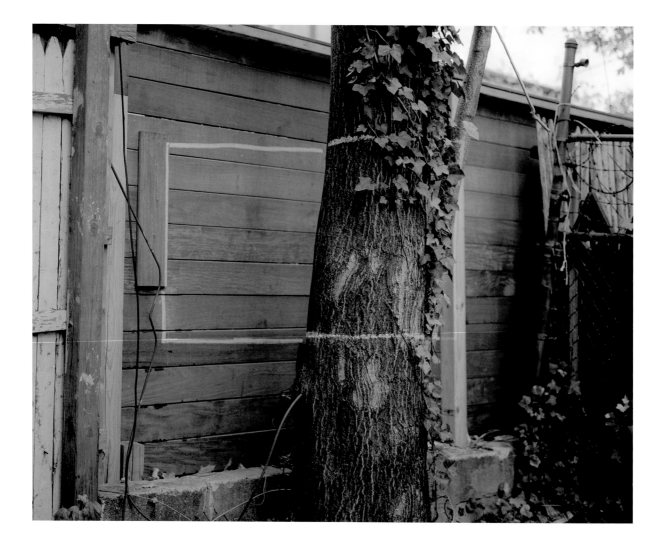

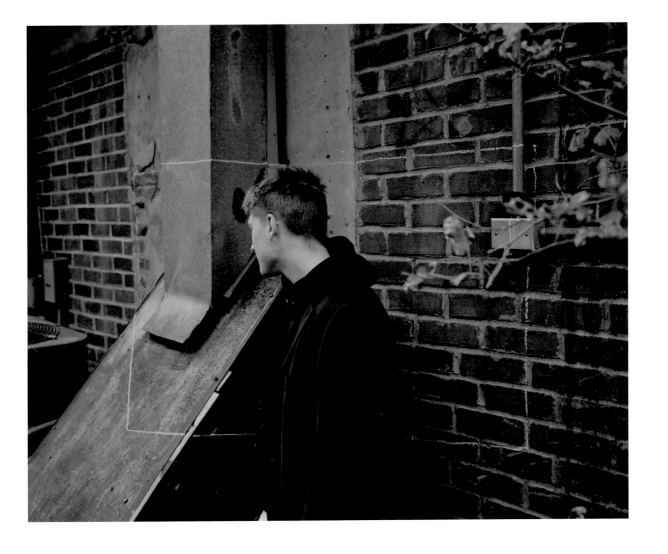

Sara Skorgan Teigen

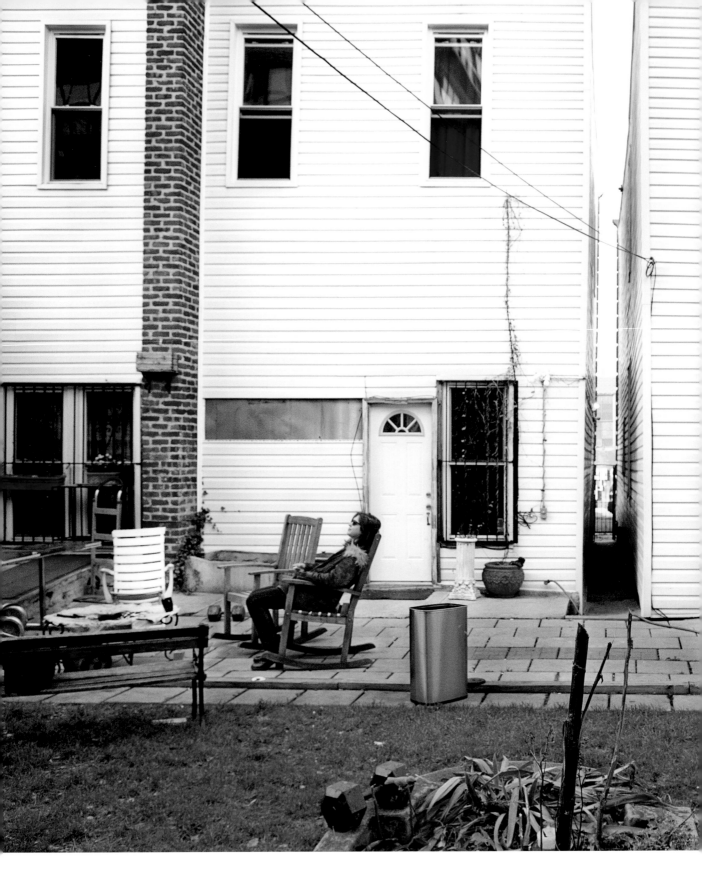

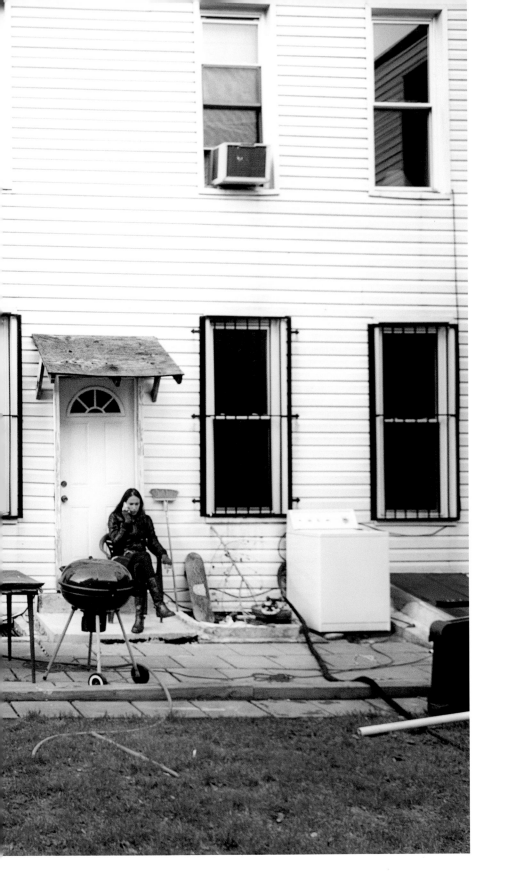

Helena Wolfenson

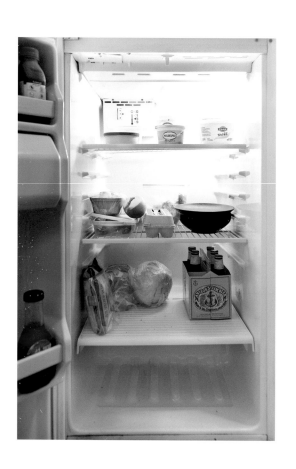
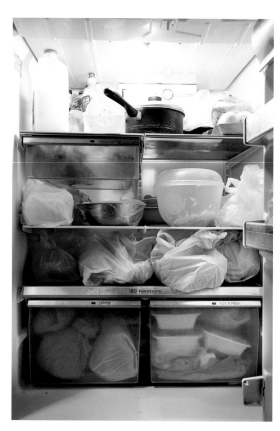

 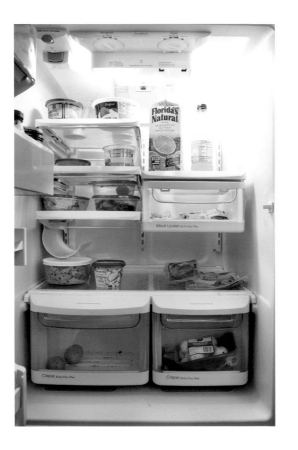 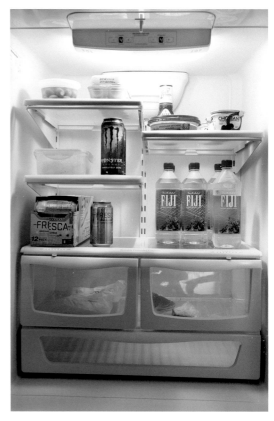

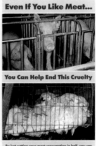

Kenneth Pizzo

FLYERS OFFERED TO ME WHILE WALKING FROM 28TH TO 59TH STREETS ON 7TH AVE AT NOON ON BLACK FRIDAY, 2011, IN THE ORDER THEY WERE COLLECTED.

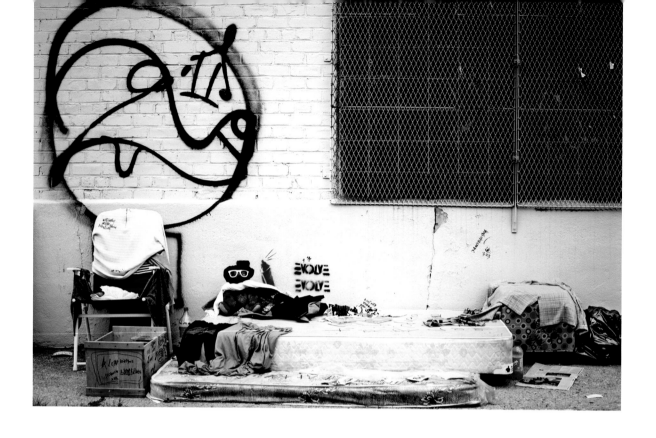

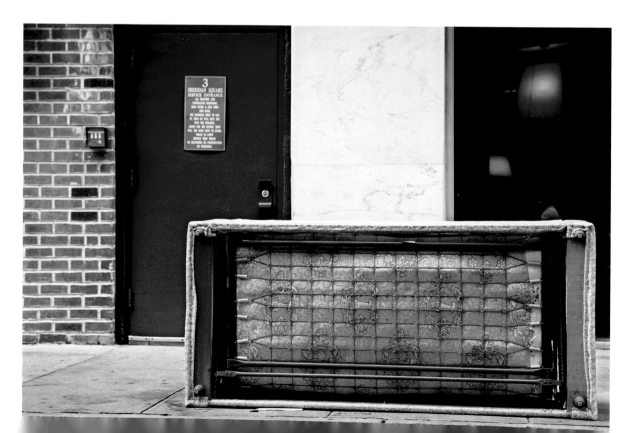

Lucia Fainzilber

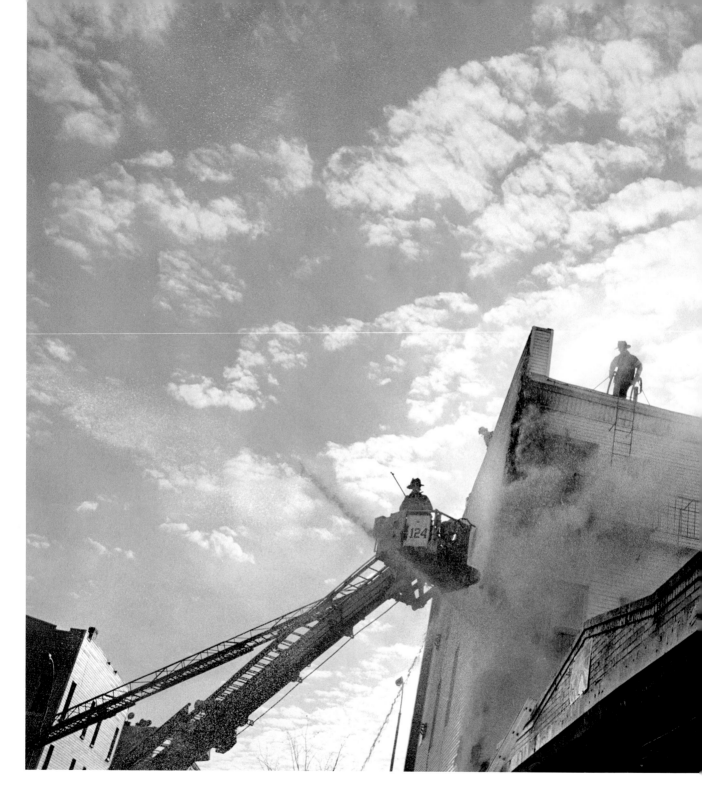

Andrew White

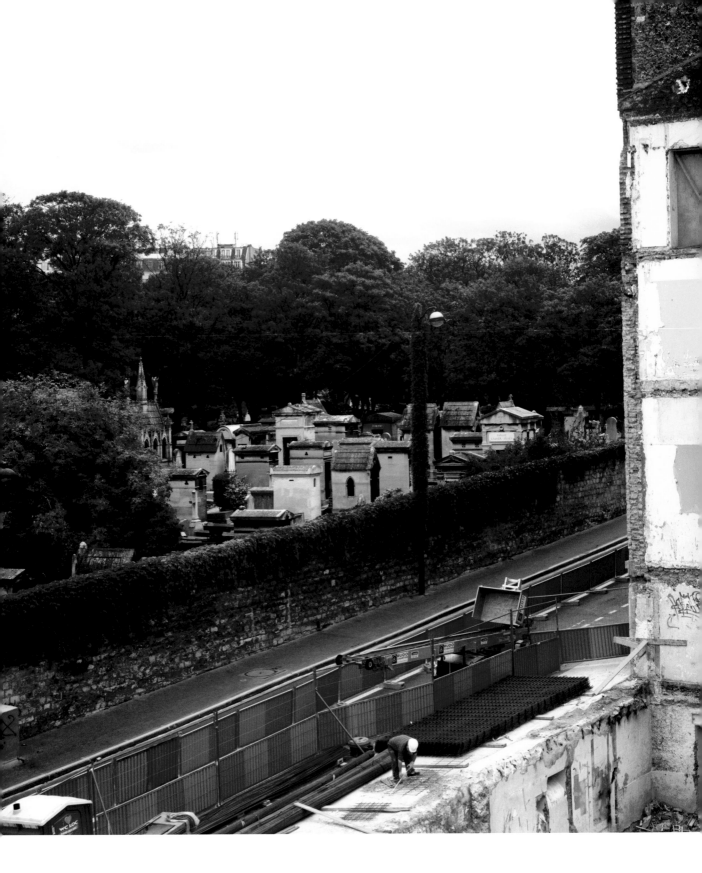

Libby Pratt

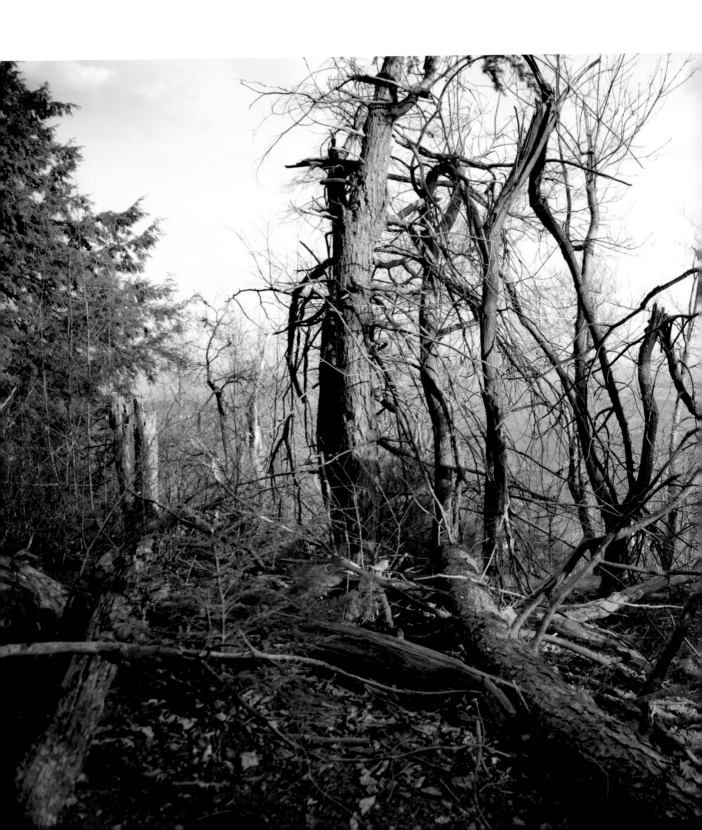

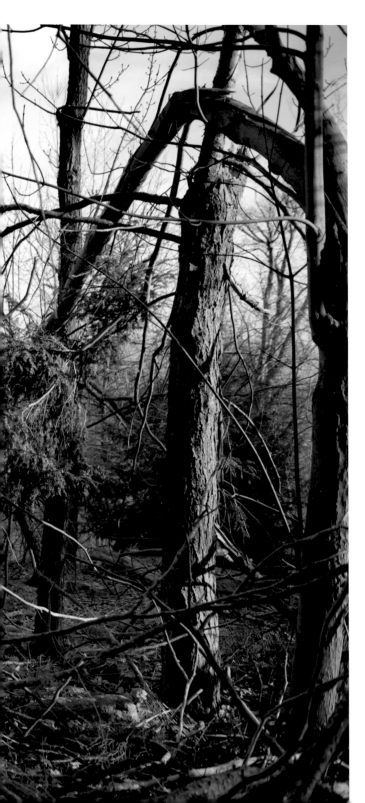

Who Understands Me But Me

I followed these signs

like an old tracker and followed the tracks deep into myself

followed the blood-spotted path,

deeper into dangerous regions, and found so many parts of myself,

who taught me water is not everything,

and gave me new eyes to see through walls,

and when they spoke, sunlight came out of their mouths,

and I was laughing at me with them,

we laughed like children and made pacts to always be loyal,

who understands me when I say this is beautiful?

Jimmy Santiago Baca

Netza Moreno

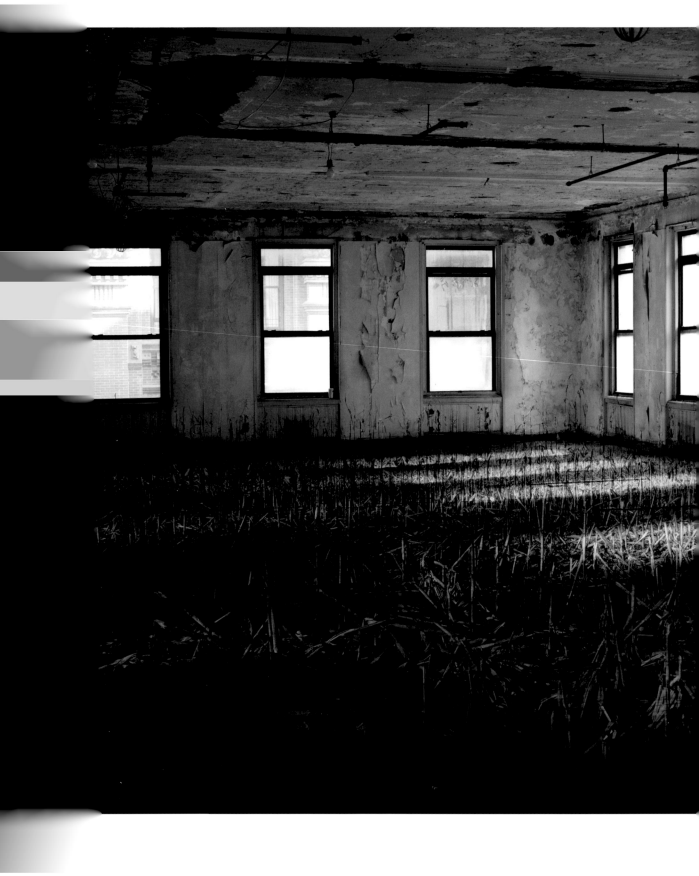

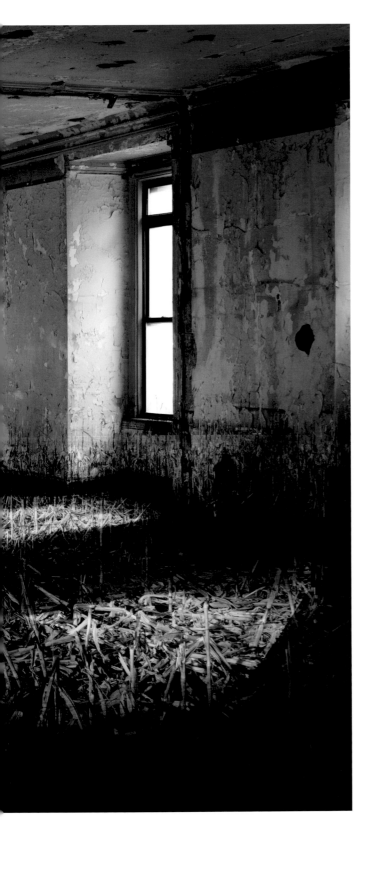

Alexia Roemmers

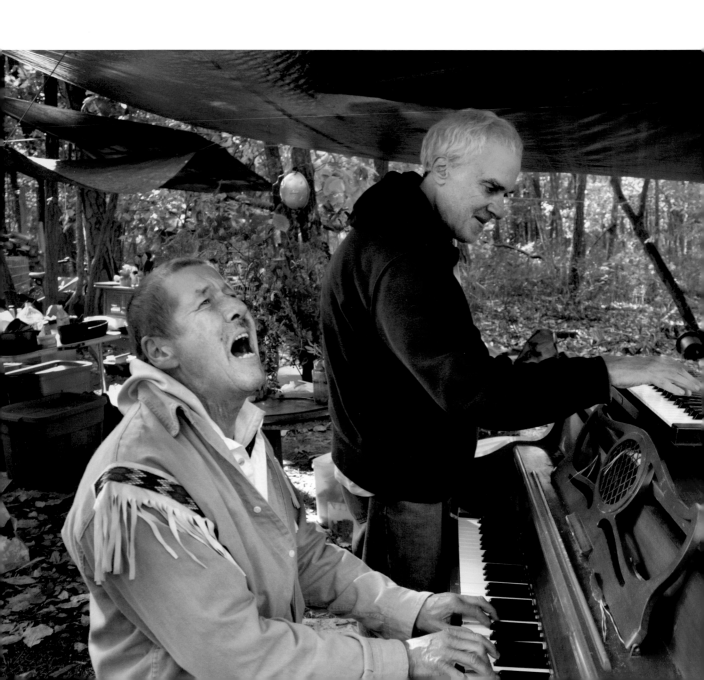

Russ Voss

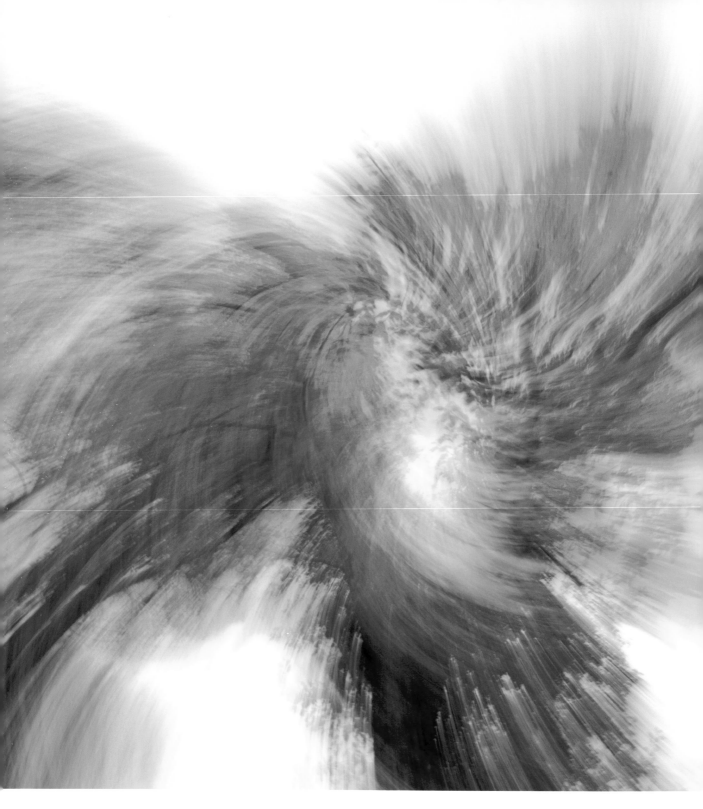

Dreaming or awake, we perceive only events that have meaning to us. *Jane Roberts*

Ashley Vivian Augustine

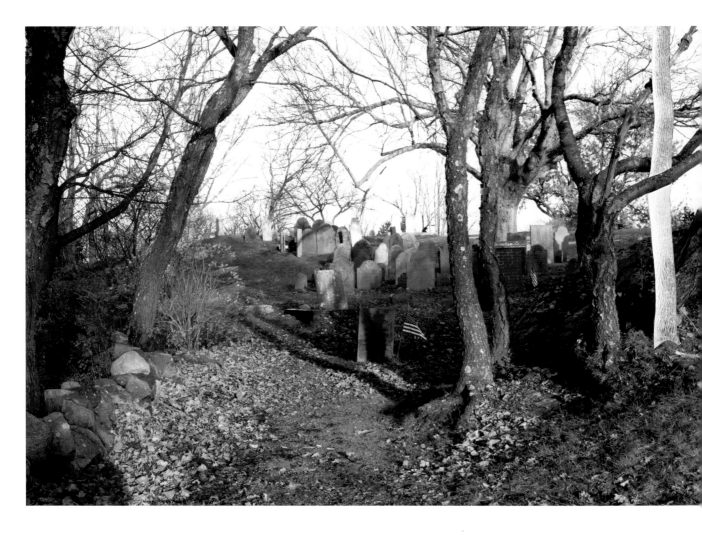

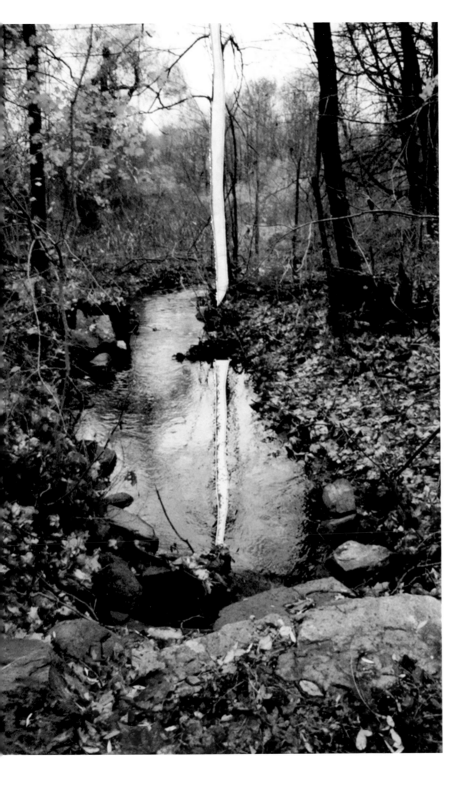

Ashley Cerciello

El día 30 de Agosto de 1956, vin[
Durango, nos pasó este accidente a[
aclamando al Santo Niño, que nos [
de salir ilesos. Por lo que en agradeci[
camos este humilde recuerdo.

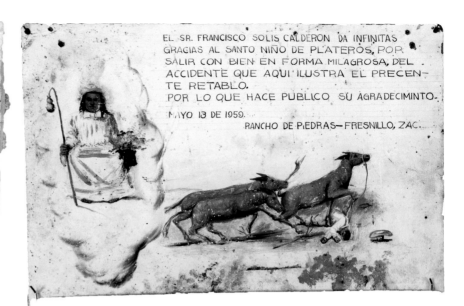

EL SR. FRANCISCO SOLIS CALDERON DA INFINITAS
GRACIAS AL SANTO NIÑO DE PLATEROS, POR
SALIR CON BIEN EN FORMA MILAGROSA, DEL
ACCIDENTE QUE AQUI ILUSTRA EL PRECEN-
TE RETABLO.
POR LO QUE HACE PUBLICO SU AGRADECIMINTO.
MAYO 13 DE 1959.
RANCHO DE PIEDRAS—FRESNILLO, ZAC.

Brian Paumier

A bird jumps across the pond, and a man thinks to himself can there be anything more with life. He ponders this a while and then returns to his parked car. He sits himself down with an uneasiness as if to try to find that one comfortable spot in the chair. He does not find it. Then he begins to search through his CD cases trying to find that one perfect song to be the total sum of all his feelings. He again does not find it. Thus he just stares for a moment out of the front window at the other parked cars. "This will have to suffice," he thinks to himself. He must move on for to be still is to die. He knows this but for some reason he cannot bring himself to move. Thus he continues to watch the birds as best he can from the confines of the car. Some time passes and he starts the car. It comes to life like a lion's roar; a declaration one could say to the world. And with that he leaves the confines of the pond, the parking lot, and the car. He has become free like the birds. He will not be going home.

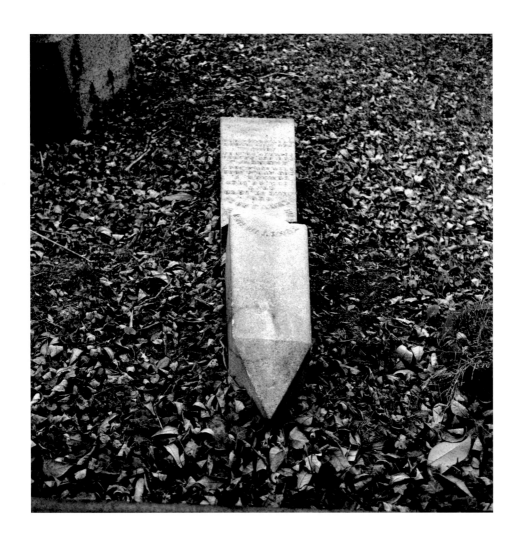

Andrew Fedynak

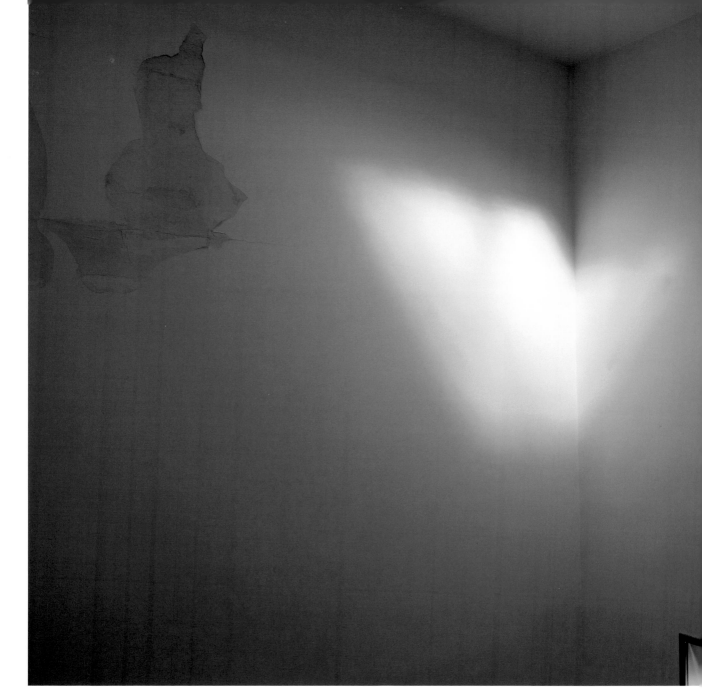

Julie Nymann

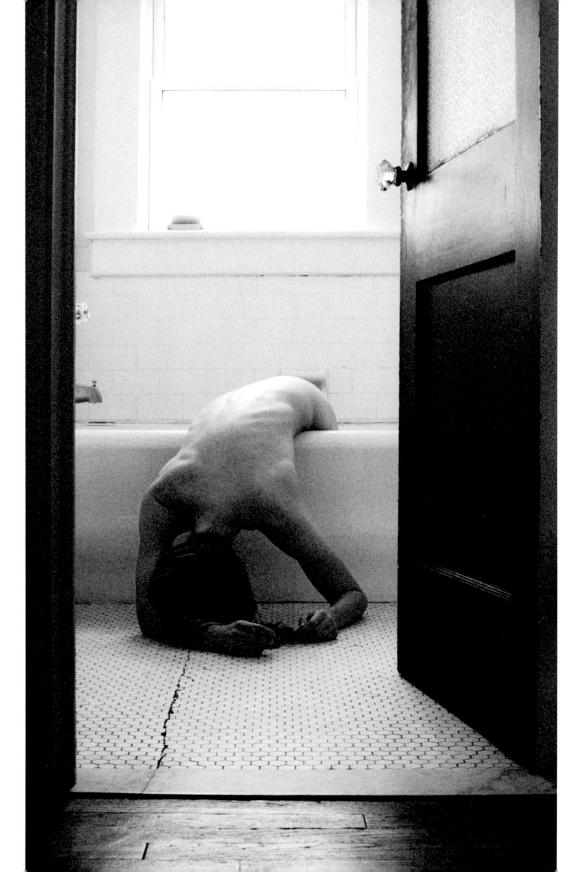

WAS IN PIECES

ERAL PIECES

HEAD, HANDS, ARMS, LEGS, FEET

SO

JUST PIECES

THE PIECES WERE ALL IN BOXES

VET

ER

ES

HAD NO WAY TO EXPLAIN IT

DON'T REMEMBER WHAT HAPPENED

DON'T REMEMBER DOING IT

I REALLY DIDN'T

HERE SHE IS

Laura Lee Revercomb

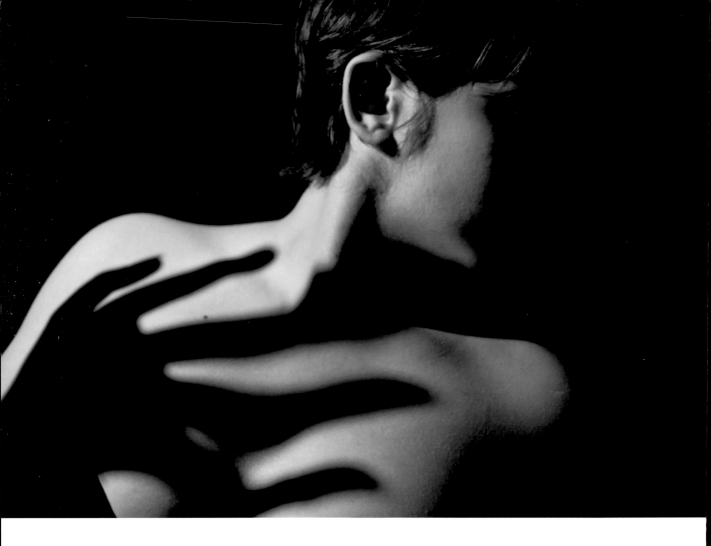

Wrapped up in darkness being pulled from below. Hell hath no wrath just truth. Falling down accepting not wishing not wanting. The landing was warm not hot. The fire flourished and the souls were torched. He was standing over his collection as if he were the proud father. I approached as if welcome; he snickered and glared. He knew what he had, the work was done. The contract was written, the line was drawn, and I was the terms. He came down to convert me but I was already a believer so he laid it in front of me: my fate, my faith, on paper, in blood. Then one thing passed through the slit in his tongue, "You are my child." My hand took the implement to pen my name and it hovered in mid-air. I looked at him for a second and lived that moment for a minute. He may be the night but I am the fear. The pen turned to water, and my heart turned to ice. Devil I will do your bidding but just not tonight.

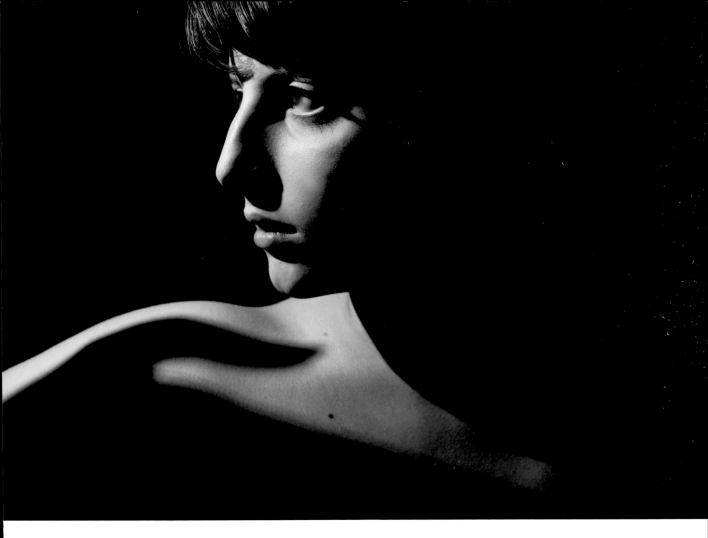

Deanna Rizzi

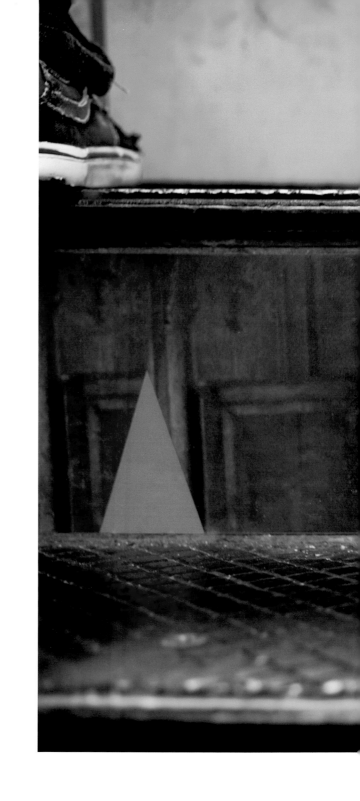

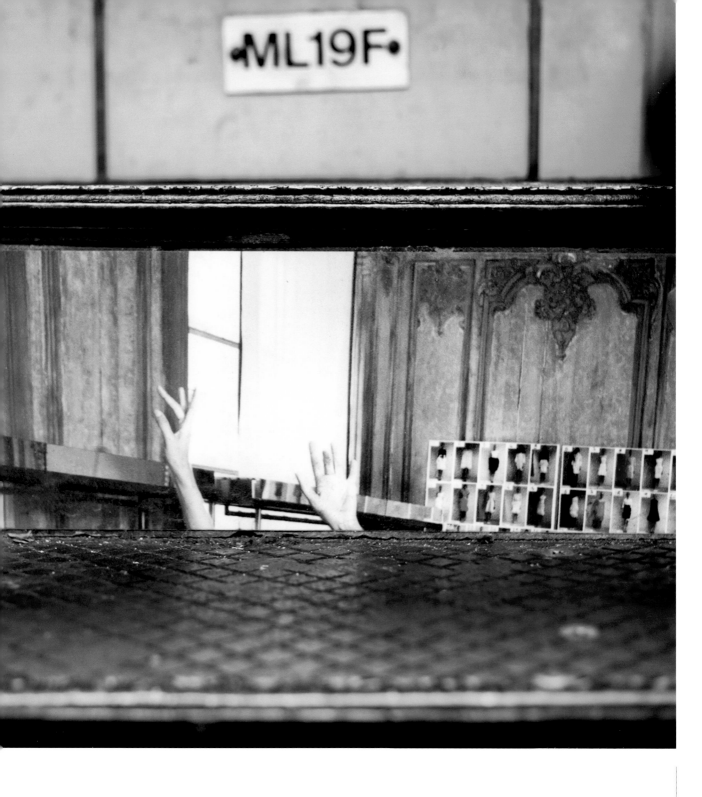

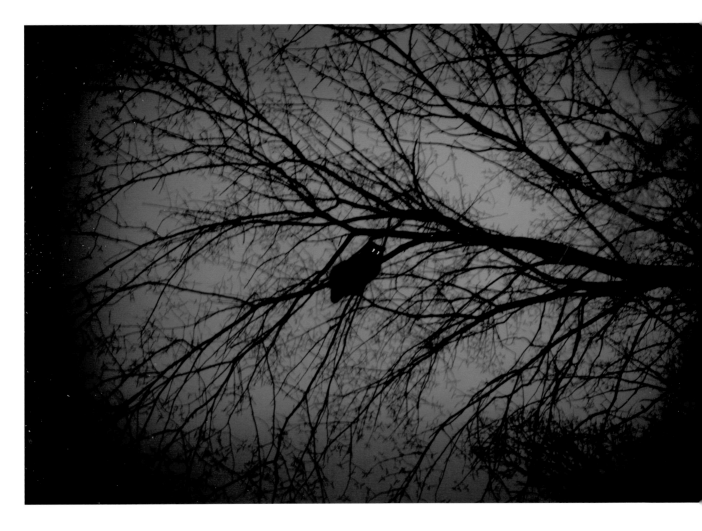

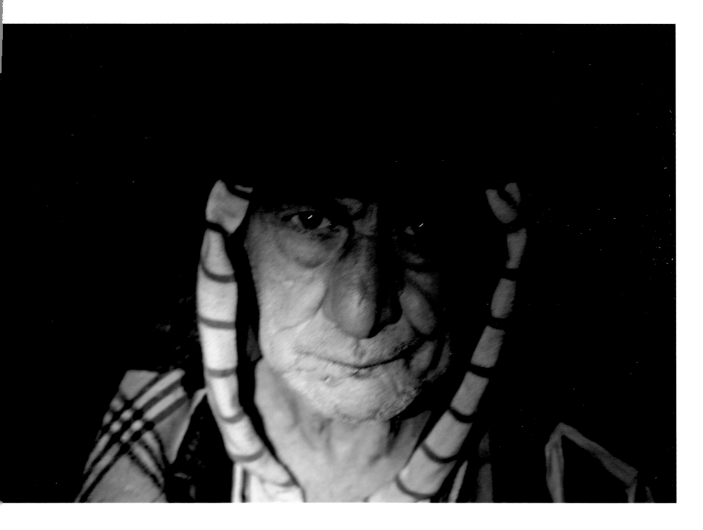

Bjorn Haldorsen

Take it with you my eyes,
so I can see you in the dark...

Take it with you my lips,
so they can whisper in your ears
how much I miss you...

Take it with you my hands,
so I can touch you in the distance...

Take it with you my heart,
only and because it belongs to you...

Take it with you my memories,
so I can't remember the pain
of living an entire life without you...

Denise Bergelino

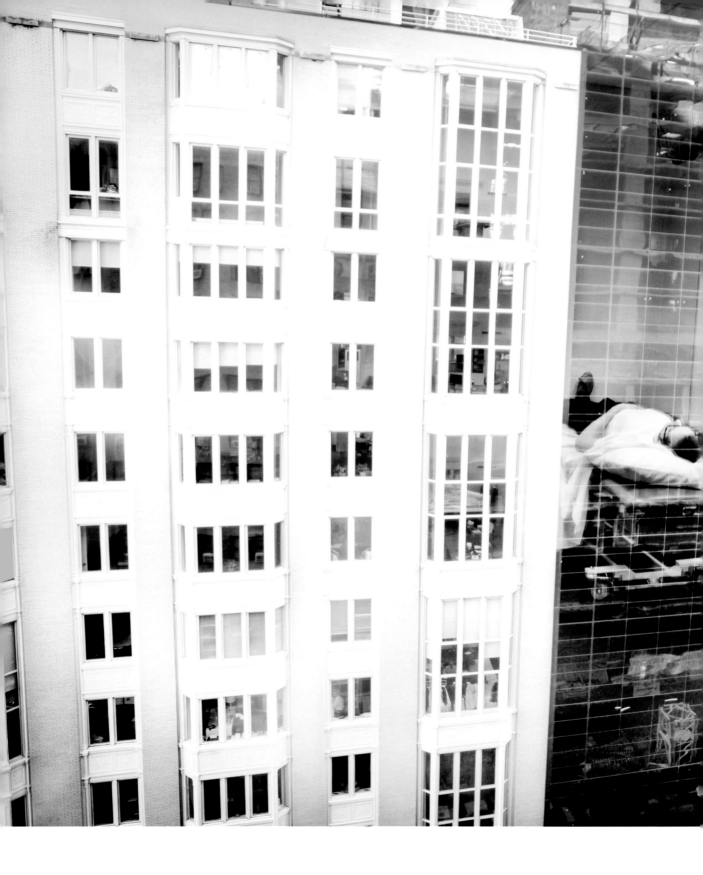

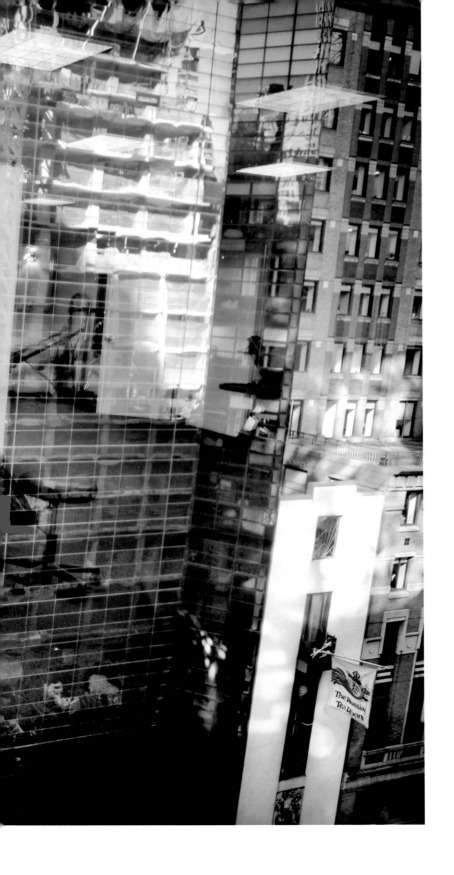

Gaia Squarci

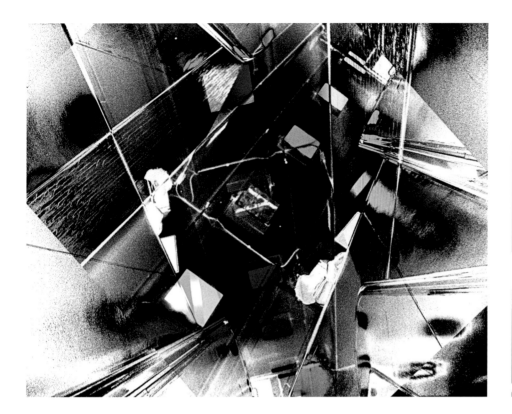

The minute you begin to have doubts, the floor under your feet starts to shake.

Kobo Abe, *Green Stockings,* 1974

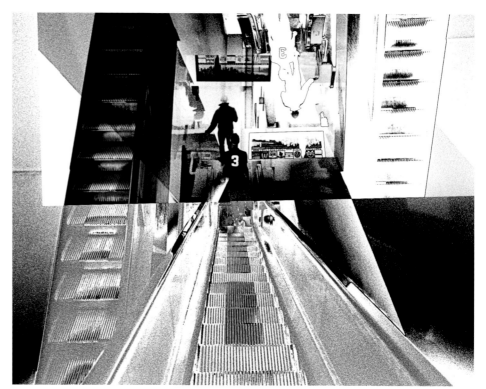

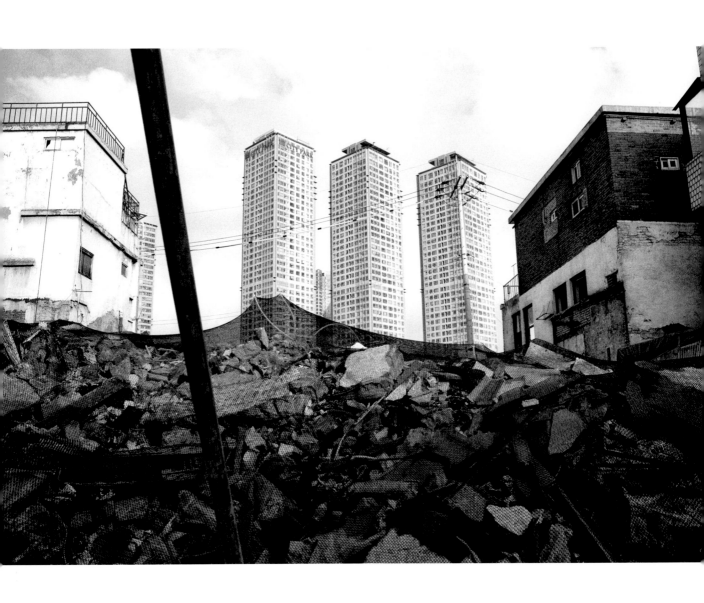

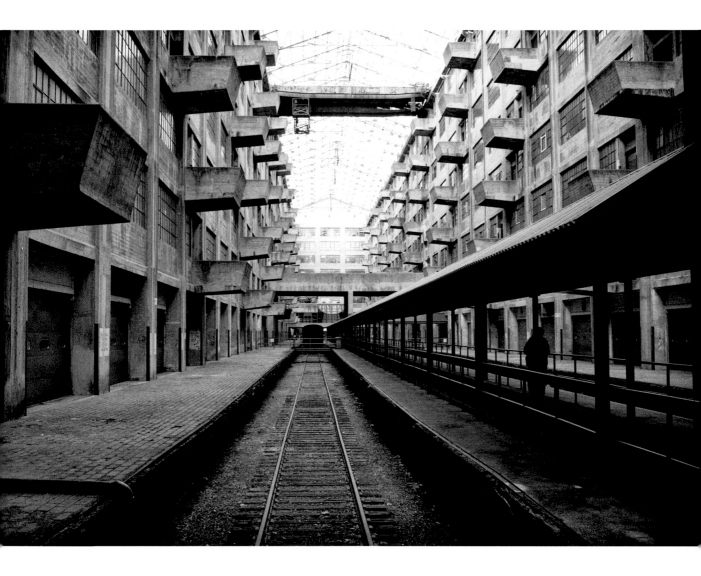

Memory ... Strange that the mind will forget so much of what only this moment has passed, and yet hold clear and bright the memory of what happened years ago; of men and women long since dead.

From John Ford's film *How Green Was My Valley* (1941)

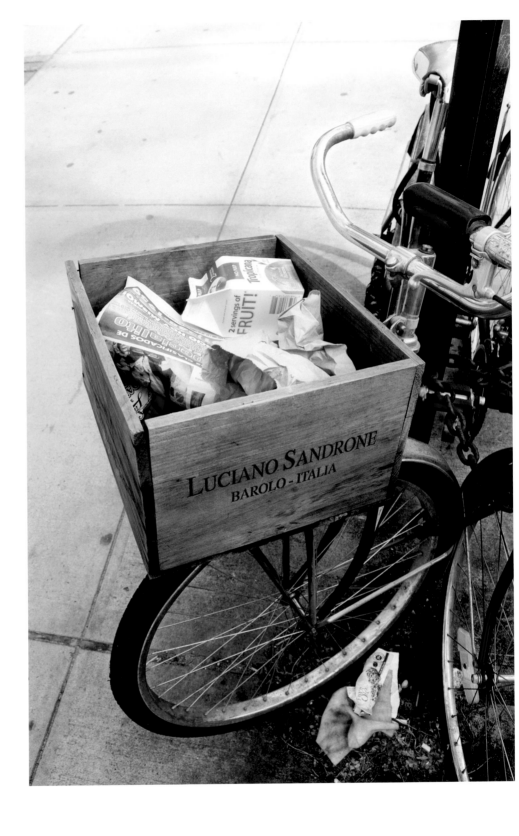

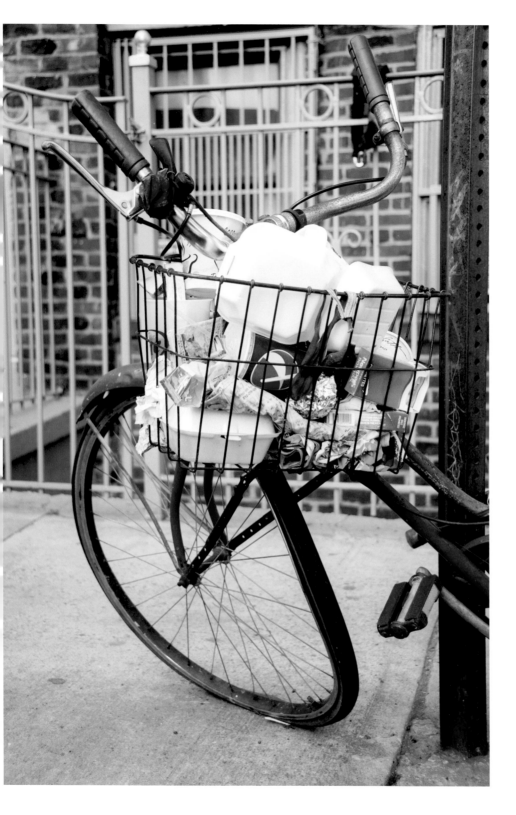

Anna Gabriela Malta

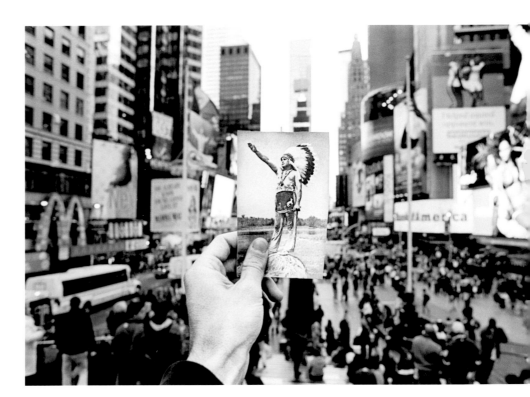

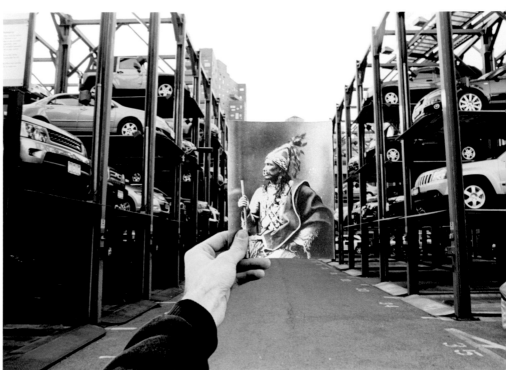

Rephotographing photographs for me has always been a great experience. Through an objective eye, I wanted to show to the first people who lived in the State of New York what this place has become.

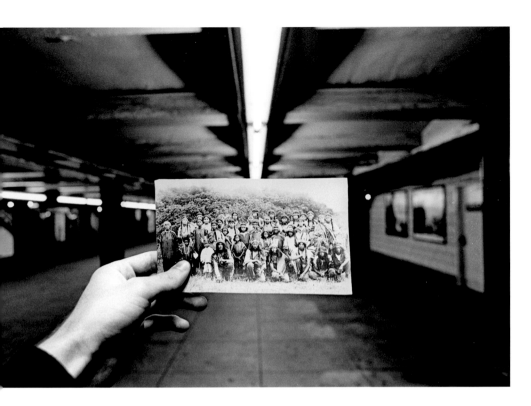

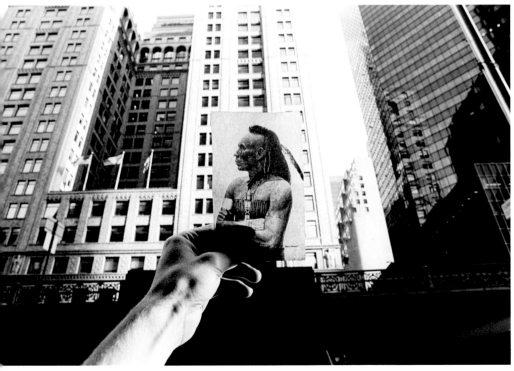

Francesco Palombi

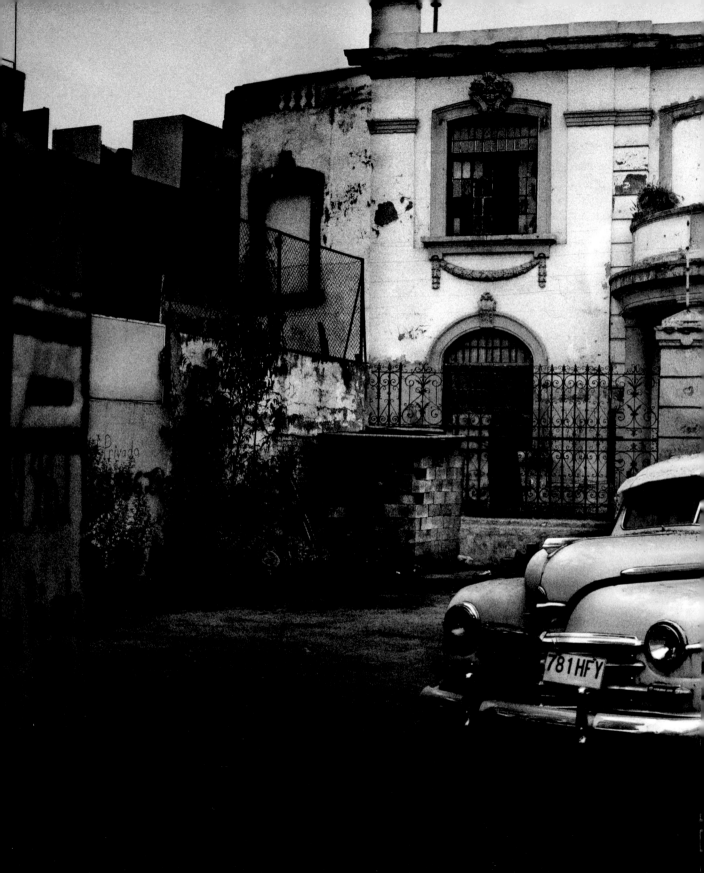

David Lundbye

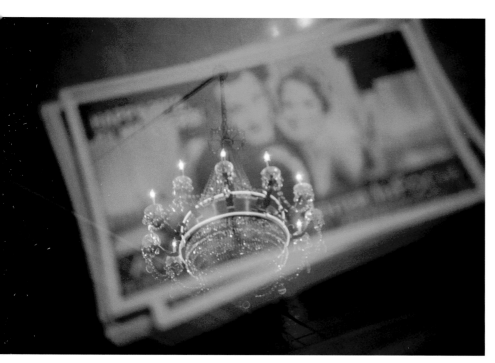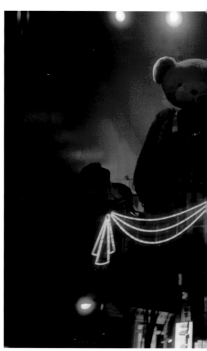

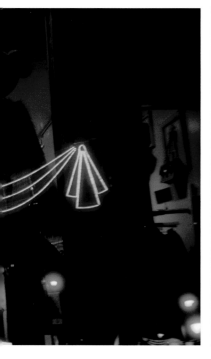

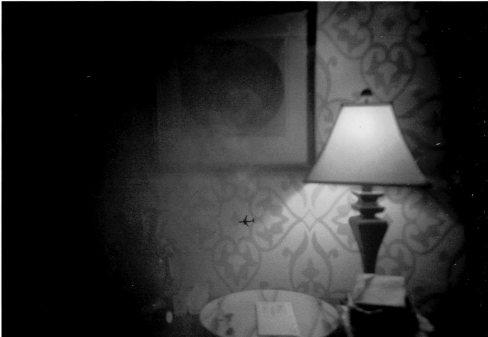

Kimberley Ross

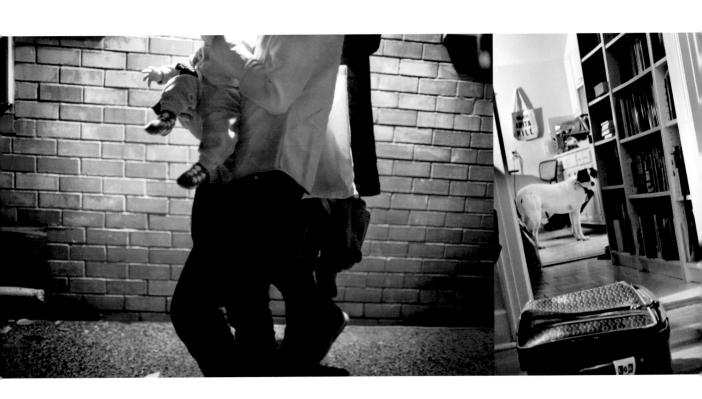

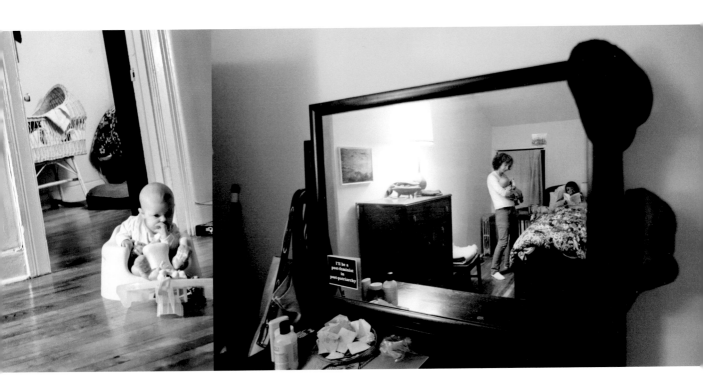

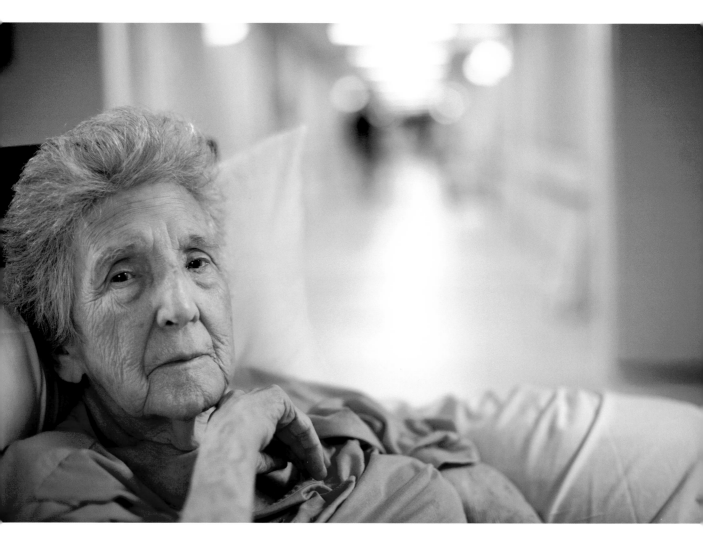

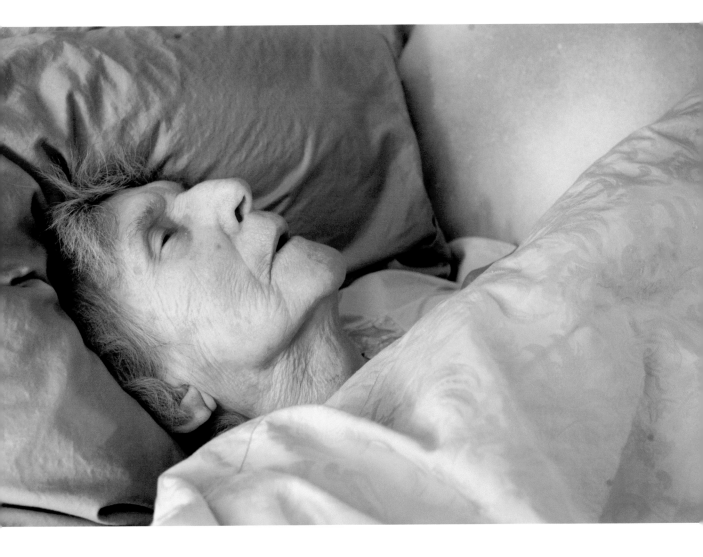

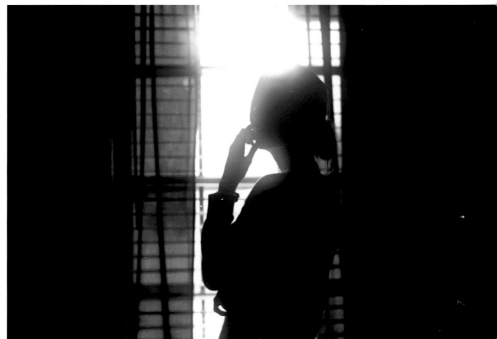

Lillian Brott

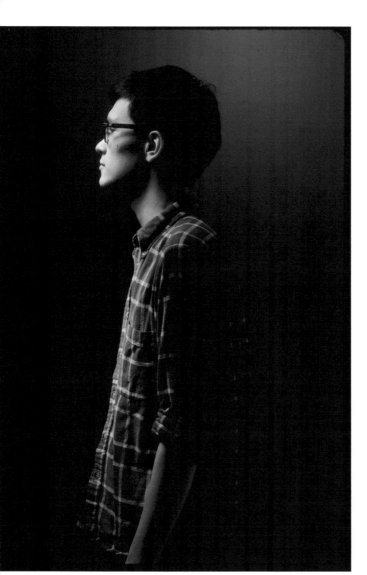
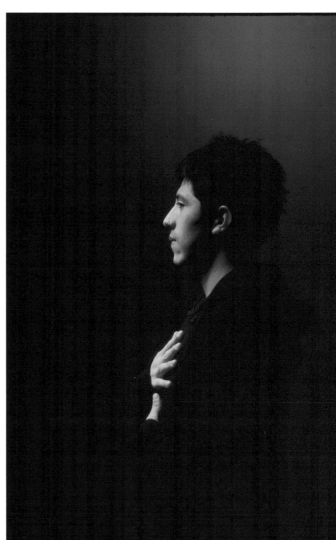

The Past is the region of sobs, the Future is the realm of song. In the one crouches Memory, clad in sackcloth and ashes, mumbling penitential prayer; in the sunshine of the other Hope flies with a free wing, beckoning to temples of success and bowers of ease.

Ambrose Bierce

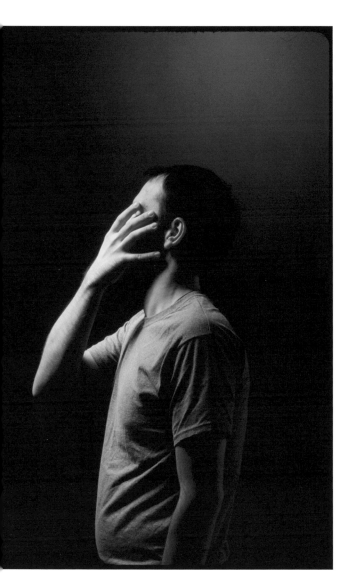 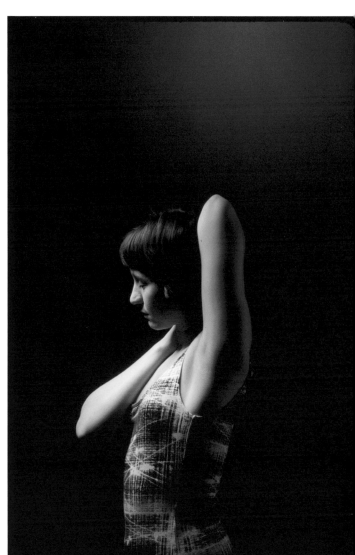

Thierry Casias

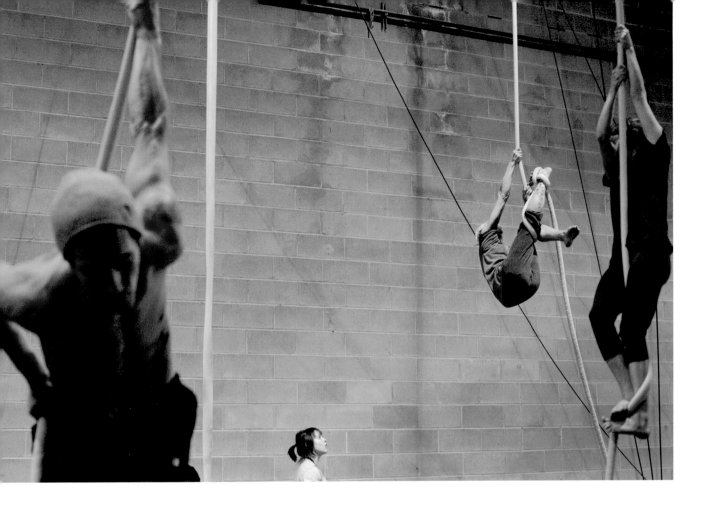

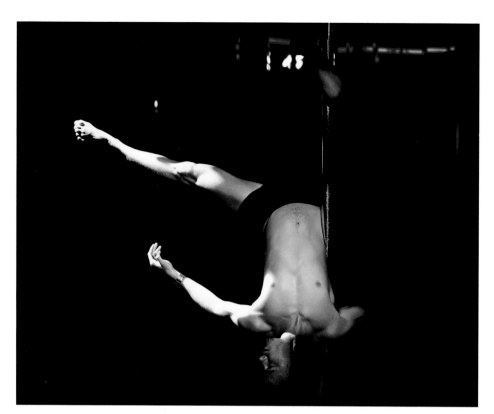

Jan Rattia

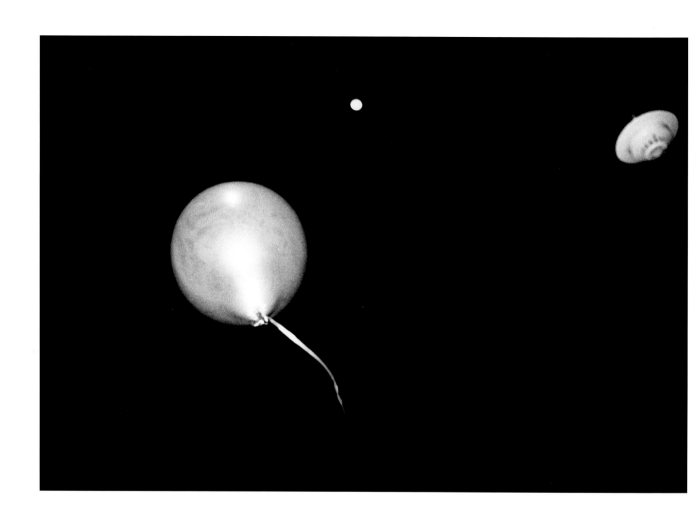

Min-Wei Ting

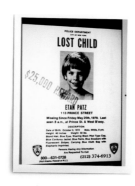

CONDOM

EXTINGUISHER

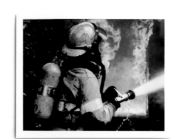

BABY BOTTLE

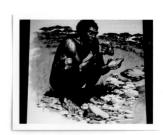

DINGLEHOPPER

WHEEL

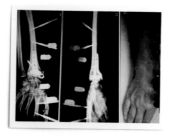

STAPLER

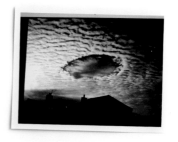

HAMMER

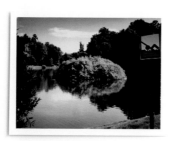

LIGHT BULB

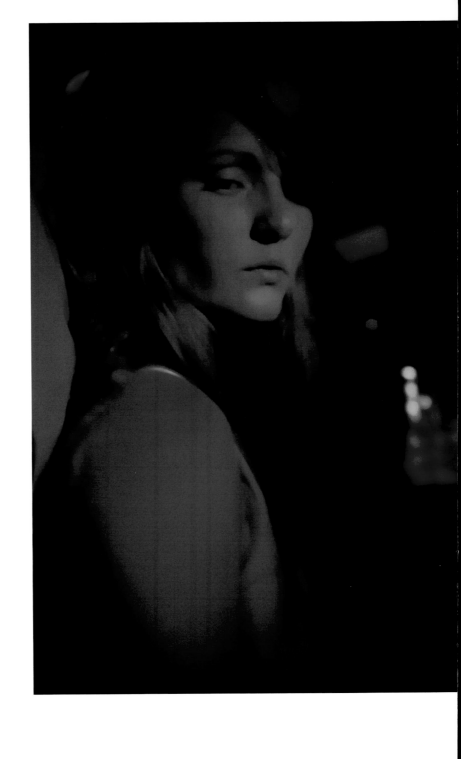

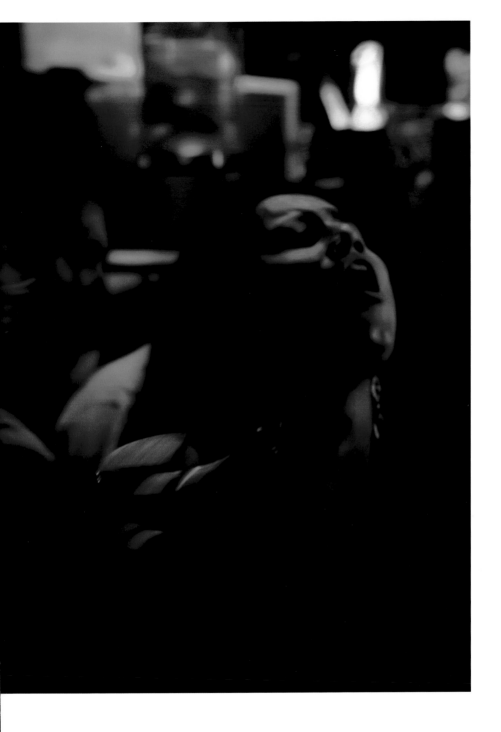

Maya Chandally

Stephen K. Schuster

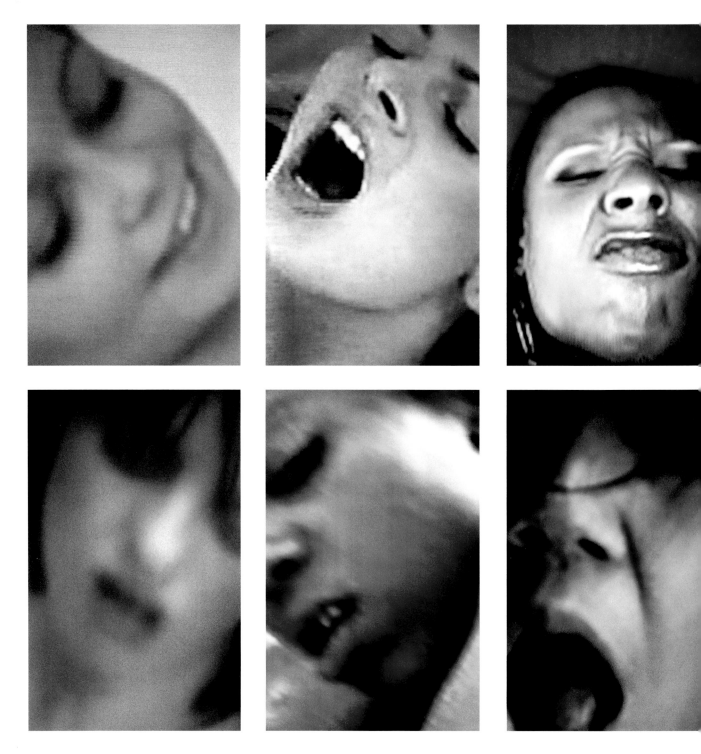

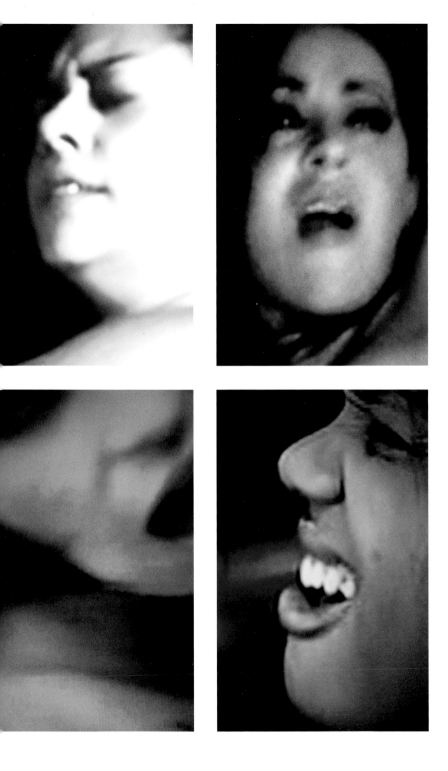

Thomas Law

P.O.V. (POINT OF VIEW)

Roberta Trentin

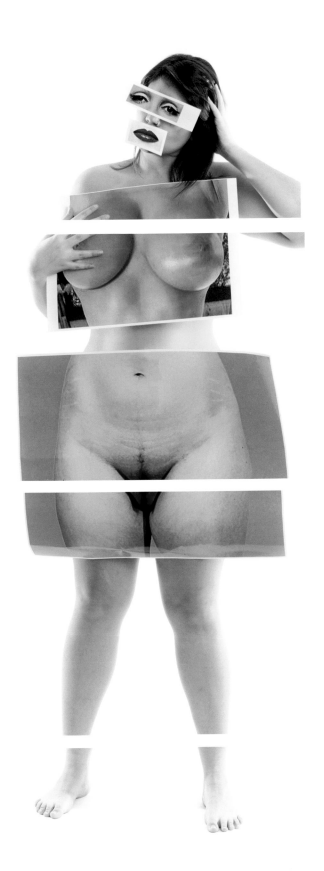

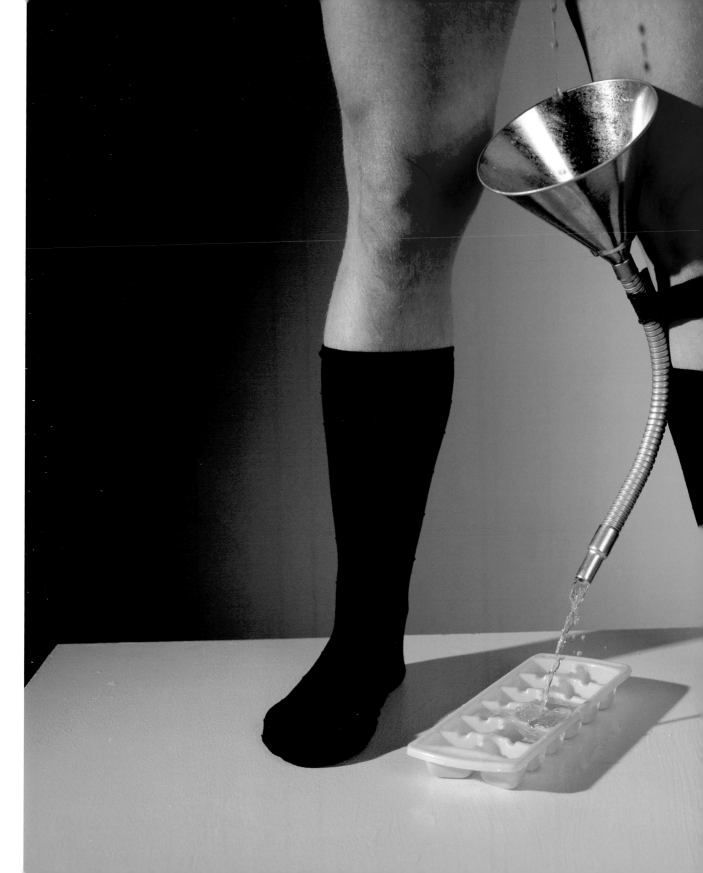

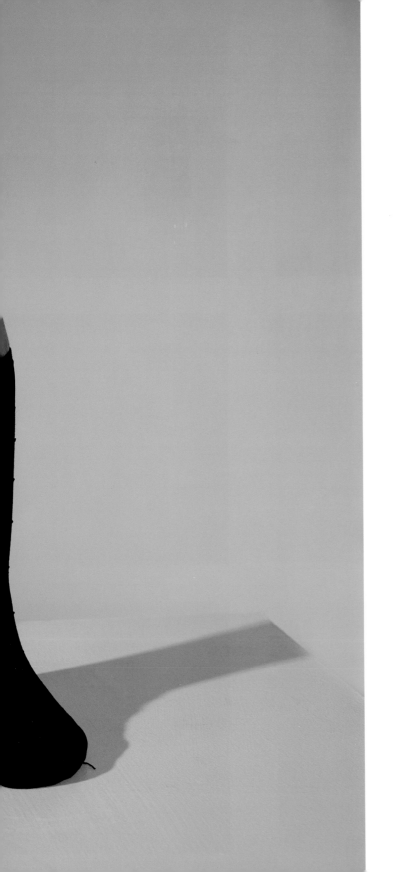

Nica Ross

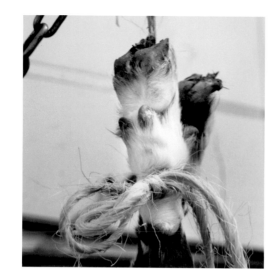
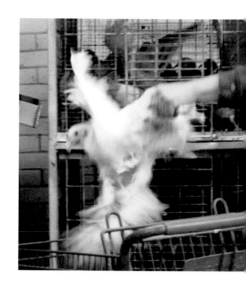
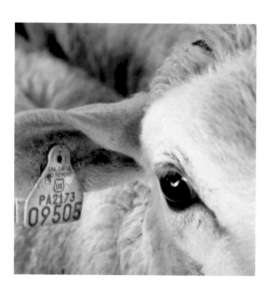
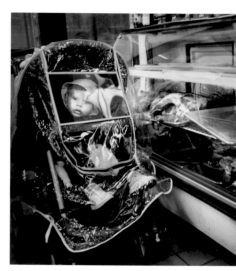
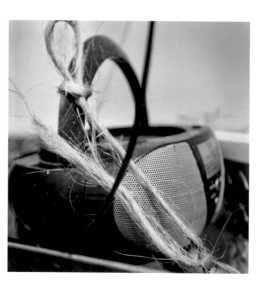
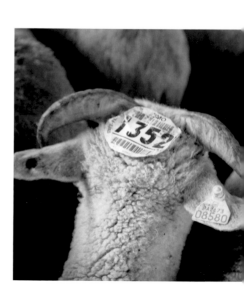

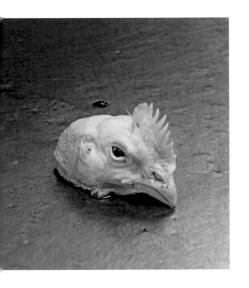

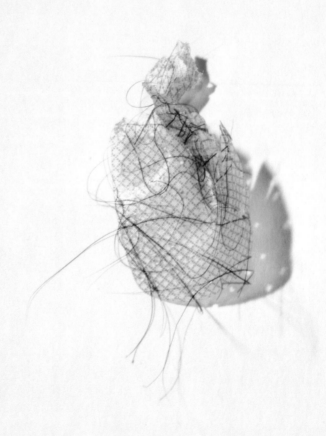

Daniel Temkin

Installation view: 3,167 preexisting holes made in collective studio space from Aug 2011 to Feb 2012, eye hooks, nails, and connectors

Michi Jigarjian

THELIBRARYOFBABELBYTHISARTYOUMAYCONTEMPLATETHEVARIATIONSOFTHE23LETTERS...THEANATOMYOFMELANCHOLY,PART2,SECT.
WHICHOTHERSCALLTHELIBRARY)ISCOMPOSEDOFANINDEFINITEANDPERHAPSINFINITENUMBEROFHEXAGONALGALLERIES,WITHVASTAIRS
EDBYVERYLOWRAILINGS.FROMANYOFTHEHEXAGONSONECANSEE,INTERMINABLY,THEUPPERANDLOWERFLOORS.THEDISTRIBUTIONOFTHE
TWENTYSHELVES,FIVELONGSHELVESPERSIDE,COVERALLTHESIDESEXCEPTTWO;THEIRHEIGHT,WHICHISTHEDISTANCEFROMFLOORTOCEI
HATOFANORMALBOOKCASE.ONEOFTHEFREESIDESLEADSTOANARROWHALLWAYWHICHOPENSONTOANOTHERGALLERY,IDENTICALTOTHEFIRST
LEFTANDRIGHTOFTHEHALLWAYTHEREARETWOVERYSMALLCLOSETS.INTHEFIRST,ONEMAYSLEEPSTANDINGUP;INTHEOTHER,SATISFYONE'
OTHROUGHHEREPASSESASPIRALSTAIRWAY,WHICHSINKSABYSMALLYANDSOARSUPWARDSTOREMOTEDISTANCES.INTHEHALLWAYTHEREISAM
UPLICATESALLAPPEARANCES.MENUSUALLYINFERFROMTHISMIRRORTHATTHELIBRARYISNOTINFINITE(IFITWERE,WHYTHISILLUSORYDU
DREAMTHATITSPOLISHEDSURFACESREPRESENTANDPROMISETHEINFINITE....LIGHTISPROVIDEDBYSOMESPHERICALFRUITWHICHBEARTH
TWO,TRANSVERSALLYPLACED,INEACHHEXAGON.THELIGHTTHEYEMITISINSUFFICIENT,INCESSANT.LIKEALLMENOFTHELIBRARY,IHAVE
VEWANDEREDINSEARCHOFABOOK,PERHAPSTHECATALOGUEOFCATALOGUES;NOWTHATMYEYESCANHARDLYDECIPHERWHATIWRITE,IAMPREPA
UESFROMTHEHEXAGONINWHICHIWASBORN.ONCEIAMDEAD,THEREWILLBENOLACKOFPIOUSHANDSTOTHROWMEOVERTHERAILING;MYGRAVEWI
MYBODYWILLSINKENDLESSLYANDDECAYANDDISSOLVEINTHEWINDGENERATEDBYTHEFALL,WHICHISINFINITE.ISAYTHATTHELIBRARYISU
RGUETHATTHEHEXAGONALROOMSAREANECESSARYFORMOFABSOLUTESPACEOR,ATLEAST,OFOURINTUITIONOFSPACE.THEYREASONTHATATR
OOMISINCONCEIVABLE(THEMYSTICSCLAIMTHATTHEIRECSTASYREVEALSTOTHEMACIRCULARCHAMBERCONTAININGAGREATCIRCULARBOOK
USANDWHICHFOLLOWSTHECOMPLETECIRCLEOFTHEWALLS;BUTTHEIRTESTIMONYISSUSPECT;THEIRWORDS,OBSCURE.THISCYCLICALBOOK
WFORMETOREPEATTHECLASSICDICTUM:THELIBRARYISASPHEREWHOSEEXACTCENTERISANYONEOFITSHEXAGONSANDWHOSECIRCUMFERENC
AREFIVESHELVESFOREACHOFTHEHEXAGON'SWALLS;EACHSHELFCONTAINSTHIRTY-FIVEBOOKSOFUNIFORMFORMAT;EACHBOOKISOFFOURHU
PAGE,OFFORTYLINES,EACHLINE,OFSOMEEIGHTYLETTERSWHICHAREBLACKINCOLOR.THEREAREALSOLETTERSONTHESPINEOFEACHBOOK;
CATEORPREFIGUREWHATTHEPAGESWILLSAY.IKNOWTHATTHISINCOHERENCEATONETIMESEEMEDMYSTERIOUS.BEFORESUMMARIZINGTHESO
,INSPITEOFITSTRAGICPROJECTIONS,ISPERHAPSTHECAPITALFACTINHISTORY)IWISHTORECALLAFEWAXIOMS.FIRST:THELIBRARYEXI
H,WHOSEIMMEDIATECOROLLARYISTHEFUTUREETERNITYOFTHEWORLD,CANNOTBEPLACEDINDOUBTBYANYREASONABLEMIND.MAN,THEIMPE
HEPRODUCTOFCHANCEORMALEVOLENTDEMIURGI;THEUNIVERSE,WITHITSELEGANTENDOWMENTOFSHELVES,OFENIGMATICALVOLUMES,O
YSFORTHETRAVELERANDLATRINESFORTHESEATEDLIBRARIAN,CANONLYBETHEWORKOFAGOD.TOPERCEIVETHEDISTANCEBETWEENTHEDIVI
ERFECTLYBLACK,INIMITABLYSYMMETRICAL.SECOND:THEORTHOGRAPHICALSYMBOLSARETWENTY-FIVEINNUMBER[1]THISFINDINGMADEI
DYEARSAGO,TOFORMULATEAGENERALTHEORYOFTHELIBRARYANDSOLVESATISFACTORILYTHEPROBLEMWHICHNOCONJECTUREHADDECIPHER
TICNATUREOFALMOSTALLTHEBOOKS.ONEWHICHMYFATHERSAWINAHEXAGONONCIRCUITFIFTEENNINETYFOURWASMADEUPOFTHELETTERSMC
ROMTHEFIRSTLINETOTHELAST.ANOTHER(VERYMUCHCONSULTEDINTHISAREA)ISAMERELABYRINTHOFLETTERS,BUTTHENEXTTOLASTPAGE
.THISMUCHISALREADYKNOWN:FOREVERYSENSIBLELINEOFSTRAIGHTFORWARDSTATEMENT,THEREARELEAGUESOFSENSELESSCACOPHONIE
OHERENCES.(IKNOWOFANUNCOUTHREGIONWHOSELIBRARIANSREPUDIATETHEVAINANDSUPERSTITIOUSCUSTOMOFFINDINGAMEANINGINBO
TOFFINDINGAMEANINGINDREAMSORINTHECHAOTICLINESOFONE'SPALM....THEYADMITTHATTHEINVENTORSOFTHISWRITINGIMITATEDTH
BOLS,BUTMAINTAINTHATTHISAPPLICATIONISACCIDENTALANDTHATTHEBOOKSSIGNIFYNOTHINGINTHEMSELVES.THISDICTUM,WESHALL
ACIOUS.)FORALONGTIMEITWASBELIEVEDTHATTHESEIMPENETRABLEBOOKSCORRESPONDEDTOPASTORREMOTELANGUAGES.ITISTRUETHAT
FIRSTLIBRARIANS,USEDALANGUAGEQUITEDIFFERENTFROMTHEONEWENOWSPEAK;ITISTRUETHATAFEWMILESTOTHERIGHTTHETONGUEISD
TYFLOORSFARTHERUP,ITISINCOMPREHENSIBLE.ALLTHIS,IREPEAT,ISTRUE,BUTFOURHUNDREDANDTENPAGESOFINALTERABLEMCV'SCA
NGUAGE,NOMATTERHOWDIALECTICALORCRUDIMENTARYITMAYBE.SOMEINSINUATEDTHATEACHLETTERCOULDINFLUENCETHEFOLLOWINGONE
NTHETHIRDLINEOFPAGE71WASNOTTHEONETHESAMESERIESMAYHAVEINANOTHERPOSITIONONANOTHERPAGE,BUTTHISVAGUETHESISDIDNO
TOFCRYPTOGRAPHS;GENERALLY,THISCONJECTUREHASBEENACCEPTED,THOUGHNOTINTHESENSEINWHICHITWASFORMULATEDBYITSORIGI
RSAGO,THECHIEFOFANUPPERHEXAGON[2]CAMEUPONABOOKASCONFUSINGASTHEOTHERS,BUTWHICHHADNEARLYTWOPAGESOFHOMOGENEOUS
AWANDERINGDECODERWHOTOLDHIMTHELINESWEREWRITTENINPORTUGUESE;OTHERSSAIDTHEYWEREYIDDISH.WITHINACENTURY,THELANG
ILLUSTRATEDWITHEXAMPLESOFVARIATIONS.THESEEXAMPLESMADEITPOSSIBLEFORALIBRARIANOFGENIUS
AMOYEDICLITHUANIANDIALECTOFGUARANI,WITHCLASSICALARABIANINFLECTIONS.THECONTENTWASALSODECIPHERED:SOMENOTIONSO
TALLAWOFTHELIBRARY.THISTHINKEROBSERVEDTHATALLTHEBOOKS,NOMATTERHOWDIVERSETHEYMIGHTBE,AREMADEUPOFTHESAMEELEME
D,THECOMMA,THETWENTYTWOLETTERSOFTHEALPHABET.HEALSOALLEGEDAFACTWHICHTRAVELERSHAVECONFIRMED:INTHEVASTLIBRARYT
BOOKS.FROMTHESETWOINCONTROVERTIBLEPREMISESHEDEDUCEDTHATTHELIBRARYISTOTALANDTHATITSSHELVESREGISTERALLTHEPOSS
TWENTYODDORTHOGRAPHICALSYMBOLS(ANUMBERWHICH,THOUGHEXTREMELYVAST,ISNOTINFINITE):EVERYTHING:THEMINUTELYDETAIL
THEARCHANGELS'AUTOBIOGRAPHIES,THEFAITHFULCATALOGUEOFTHELIBRARY,THOUSANDSANDTHOUSANDSOFFALSECATALOGUES,THED
ACYOFTHOSECATALOGUES,THEDEMONSTRATIONOFTHEFALLACYOFTHETRUECATALOGUE,THEGNOSTICGOSPELOFBASILIDES,THECOMMENTA
MENTARYONTHECOMMENTARYONTHATGOSPEL,THETRUESTORYOFYOURDEATH,THETRANSLATIONOFEVERYBOOKINALLLANGUAGES,THEINTER
NALLBOOKS.WHENITWASPROCLAIMEDTHATTHELIBRARYCONTAINEDALLBOOKS,THEFIRSTIMPRESSIONWASONEOFEXTRAVAGANTHAPPINESS
TOBETHEMASTERSOFANINTACTANDSECRETTREASURE.THEREWASNOPERSONALORWORLDPROBLEMWHOSEELOQUENTSOLUTIONDIDNOTEXISTI
RSEWASJUSTIFIED,THEUNIVERSESUDDENLYUSURPEDTHEUNLIMITEDDIMENSIONSOFHOPE.ATTHATTIMEAGREATDEALWASSAIDABOUTTHEV
OLOGYANDPROPHECYWHICHVINDICATEDFORALLTIMETHEACTSOFEVERYMANINTHEUNIVERSEANDRETAINEDPRODIGIOUSARCANAFORHISFUT
EDYABANDONEDTHEIRSWEETNATIVEHEXAGONSANDRUSHEDUPTHESTAIRWAYS,URGEDONBYTHEVAININTENTIONOFFINDINGTHEIRVINDICAT
UTEDINTHENARROWCORRIDORS,PROFERREDDARKCURSES,STRANGLEDEACHOTHERONTHEDIVINESTAIRWAYS,FLUNGTHEDECEPTIVEBOOKSI
EIRDEATHCASTDOWNINASIMILARFASHIONBYTHEINHABITANTSOFREMOTEREGIONS.OTHERSWENTMAD....THEVINDICATIONSEXIST(IHAVE
RSONSOFTHEFUTURE,TOPERSONSWHOAREPERHAPSNOTIMAGINARY)BUTTHESEARCHERSDIDNOTREMEMBERTHATTHEPOSSIBILITYOFAMAN'S
,ORSOMETREACHEROUSVARIATIONTHEREOF,CANBECOMPUTEDASZERO.ATTHATTIMEITWASALSOHOPEDTHATACLARIFICATIONOFHUMANITY
ORIGINOFTHELIBRARYANDOFTIME--MIGHTBEFOUND.ITISVERISIMILARTHATTHESEGRAVEMYSTERIESCOULDBEEXPLAINEDINWORDS:IFT
ERSISNOTSUFFICIENT,THEMULTIFORMLIBRARYWILLHAVEPRODUCEDTHEUNPRECEDENTEDLANGUAGEREQUIRED,WITHITSVOCABULARIESA
TURIESNOWMENHAVEEXHAUSTEDTHEHEXAGONS...THEREAREOFFICIALSEARCHERS,INQUISITORS.IHAVESEENTHEMINTHEPERFORMANCEO
WAYSARRIVEEXTREMELYTIREDFROMTHEIRJOURNEYS;THEYSPEAKOFABROKENSTAIRWAYWHICHALMOSTKILLEDTHEM;THEYTALKWITHTHELI
STAIRS;SOMETIMESTHEYPICKUPTHENEARESTVOLUMEANDLEAFTHROUGHIT,LOOKINGFORINFAMOUSWORDS.OBVIOUSLY,NOONEEXPECTSTO
SNATURAL,THISINORDINATEHOPEWASFOLLOWEDBYANEXCESSIVEDEPRESSION.THECERTITUDETHATSOMESHELFINSOMEHEXAGONHELDPRE
EPRECIOUSBOOKSWEREINACCESSIBLE,SEEMEDALMOSTINTOLERABLE.ABLASPHEMOUSSECTSUGGESTEDTHATTHESEARCHESSHOULDCEASEA
GLELETTERSANDSYMBOLSUNTILTHEYCONSTRUCTED,BYANIMPROBABLEGIFTOFCHANCE,THESECANONICALBOOKS.THEAUTHORITIESWEREO
DERS.THESECTDISAPPEARED,BUTINMYCHILDHOODIHAVESEENOLDMENWHO,FORLONGPERIODSOFTIME,WOULDHIDEINTHELATRINESWITHS
DDENDICECUPANDFEEBLYMIMICTHEDIVINEDISORDER.OTHERS,INVERSELY,BELIEVEDTHATITWASFUNDAMENTALTOELIMINATEUSELESSW
XAGONS,SHOWEDCREDENTIALSWHICHWERENOTALWAYSFALSE,LEAFEDTHROUGHAVOLUMEWITHDISPLEASUREANDCONDEMNEDWHOLESHELVES
CFURORCAUSEDTHESENSELESSPERDITIONOFMILLIONSOFBOOKS.THEIRNAMEISEXECRATED,BUTTHOSEWHODEPLORETHE``TREASURES''D
EGLECTTWONOTABLEFACTS.ONE:THELIBRARYISSOENORMOUSTHATANYREDUCTIONOFHUMANORIGINISINFINITESIMAL.THEOTHER:EVERY
EABLE,BUT(SINCETHELIBRARYISTOTAL)THEREAREALWAYSSEVERALHUNDREDTHOUSANDIMPERFECTFACSIMILES:WORKSWHICHDIFFERON
OUNTERTOGENERALOPINION,IVENTURETOSUPPOSETHATTHECONSEQUENCESOFTHEPURIFIERS'DEPREDATIONSHAVEBEENEXAGGERATEDBY
SPRODUCED.THEYWEREURGEDONBYTHEDELIRIUMOFTRYINGTOREACHTHEBOOKSINTHECRIMSONHEXAGON:BOOKSWHOSEFORMATISSMALLERT
ILLUSTRATEDANDMAGICAL.WEALSOKNOWOFANOTHERSUPERSTITIONOFTHATTIME:THATOFTHEMANOFTHEBOOK.ONSOMESHELFINSOMEHEXA
MUSTEXISTABOOKWHICHISTHEFORMULAANDPERFECTCOMPENDIUMOFALLTHEREST:SOMELIBRARIANHASGONETHROUGHITANDHEISANALOGO
EOFTHISZONEVESTIGESOFTHISREMOTEFUNCTIONARY'SCULTSTILLPERSIST.MANYWANDEREDINSEARCHOFHIM.FORACENTURYTHEYHAVEE
VARIEDAREAS.HOWCOULDONELOCATETHEVENERATEDANDSECRETHEXAGONWHICHHOUSEDHIM?SOMEONEPROPOSEDAREGRESSIVEMETHOD:TO
RSTBOOKBWHICHINDICATESA'SPOSITION;TOLOCATEBOOKB,CONSULTFIRSTABOOKC,ANDSOONTOINFINITY...INADVENTURESUCHASTH
DWASTEDMYYEARS.ITDOESNOTSEEMUNLIKELYTOMETHATTHEREISATOTALBOOKONSOMESHELFOFTHEUNIVERSE;[3]IPRAYTOTHEUNKNOWNG
EVENTHOUGHITWERETHOUSANDSOFYEARSAGO!--MAYHAVEEXAMINEDANDREADIT.IFHONORANDWISDOMANDHAPPINESSARENOTFORME,LETT
VENEXIST,THOUGHMYPLACEBEINHELL.LETMEBEOUTRAGEDANDANNIHILATED,BUTFORONEINSTANT,INONEBEING,LETYOURENORMOUSLIB
PIOUSMAINTAINTHATNONSENSEISNORMALINTHELIBRARYANDTHATTHEREASONABLE(ANDEVENHUMBLEANDPURECOHERENCE)ISANALMOSTM
EYSPEAK(IKNOW)OFTHE``FEVERISHLIBRARYWHOSECHANCEVOLUMESARECONSTANTLYINDANGEROFCHANGINGINTOOTHERSANDAFFIRM,NE
INGLIKEADELIRIOUSDIVINITY.''THESEWORDS,WHICHNOTONLYDENOUNCETHEDISORDERBUTEXEMPLIFYITASWELL,NOTORIOUSLYPROVE
LETASTEANDDESPERATEIGNORANCE.INTRUTH,THELIBRARYINCLUDESALLVERBALSTRUCTURES,ALLVARIATIONSPERMITTEDBYTHETWENT
MBOLS,BUTNOTASINGLEEXAMPLEOFABSOLUTENONSENSE.ITISUSELESSTOOBSERVETHATTHEBESTVOLUMEOFTHEMANYHEXAGONSUNDERMYA
EDTHECOMBEDTHUNDERCLAPANDANOTHERTHEPLASTERCRAMPANDANOTHERAXAXAXASMLÖ.THESEPHRASES,ATFIRSTGLANCEINCOHERENT,C
NACRYPTOGRAPHICALORALLEGORICALMANNER;SUCHAJUSTIFICATIONISVERBALAND,EXHYPOTHESI,ALREADYFIGURESINTHELIBRARY.I
TEASYLLABLEWHICHISNOTFILLEDWITHTENDERNESSANDFEAR,WHICHISNOT,INONEOFTHESELANGUAGES,THEPOWERFULNAMEOFAGOD.TOS
LOGY.THISWORDANDUSELESSEPISTLEALREADYEXISTSINONEOFTHETHIRTYVOLUMESOFTHEFIVESHELVESOFONEOFTHEINNUMERABLEHEX
ONASWELL.(ANNUMBEROFPOSSIBLELANGUAGESUSETHESAMEVOCABULARY;INSOMEOFTHEM,THESYMBOLLIBRARYALLOWSTHECORRECTDEF
LASTINGSYSTEMOFHEXAGONALGALLERIES,BUTLIBRARYISBREADORPYRAMIDORANYTHINGELSE,ANDTHESESEVENWORDSWHICHDEFINEITH
OREADME,AREYOUSUREOFUNDERSTANDINGMYLANGUAGE?)THEMETHODICALTASKOFWRITINGDISTRACTSMEFROMTHEPRESENTSTATEOFMEN.
THINGHASBEENWRITTENNEGATESUSORTURNSUSINTOPHANTOMS.IKNOWOFDISTRICTSINWHICHTHEYOUNGMENPROSTRATETHEMSELVESBEFO
GESINABARBAROUSMANNER,BUTTHEYDONOTKNOWHOWTODECIPHERASINGLELETTER.EPIDEMICS,HERETICALCONFLICTS,PEREGRINATION
ERATEINTOBANDITRY,HAVEDECIMATEDTHEPOPULATION.IBELIEVEIHAVEMENTIONEDSUICIDES,MOREANDMOREFREQUENTWITHTHEYEARS
ARFULNESSDECEIVEME,BUTISUSPECTTHATTHEHUMANSPECIES--THEUNIQUESPECIES--ISABOUTTOBEEXTINGUISHED,BUTTHELIBRARYW
,SOLITARY,INFINITE,PERFECTLYMOTIONLESS,EQUIPPEDWITHPRECIOUSVOLUMES,USELESS,INCORRUPTIBLE,SECRET.IHAVEJUSTWR
E.''IHAVENOTINTERPOLATEDTHISADJECTIVEOUTOFRHETORICALHABIT;ISAYTHATITISNOTILLOGICALTOTHINKTHATTHEWORLDISINFI
OBELIEVEDTOPOSTULATETHATINTHEMNOTEPLACESTHECORRIDORSANDSTAIRWAYSANDHEXAGONSCANCONCEIVABLYCOMETOANEND--WHICHISA
ITTOBEWITHOUTLIMITFORGETTHATTHEPOSSIBLENUMBEROFBOOKSDOESHAVESUCHALIMIT.IVENTURETOSUGGESTTHISSOLUTIONTOTHEAN
RYISUNLIMITEDANDCYCLICAL.IFANETERNALTRAVELERWERETOCROSSITINANYDIRECTION,AFTERCENTURIESHEWOULDSEETHATTHESAME
THESAMEDISORDER(WHICH,THUSREPEATED,WOULDBEANORDER:THEORDER).MYSOLITUDEISGLADDENEDBYTHISELEGANTHOPE.[4][1]TH
ESNOTCONTAINEDIGITSORCAPITALLETTERS.THEPUNCTUATIONHASBEENLIMITEDTOTHECOMMAANDTHEPERIOD.THESETWOSIGNS,THESPAC
ERSOFTHEALPHABETARETHETWENTY-FIVESYMBOLSCONSIDEREDSUFFICIENTBYTHISUNKNOWNAUTHOR.(EDITOR'SNOTE.)[2]BEFORE,TH
EEHEXAGONS.SUICIDEANDPULMONARYDISEASESHAVEDESTROYEDTHATPROPORTION.AMEMORYOFUNSPEAKABLEMELANCHOLY:ATTIMESIHA
STHROUGHCORRIDORSANDALONGPOLISHEDSTAIRWAYSWITHOUTFINDINGASINGLELIBRARIAN.[3]IREPEAT:ITSUFFICESTHATABOOKBEP
NLYTHEIMPOSSIBLEISEXCLUDED.FOREXAMPLE:NOBOOKCANBEALADDER,ALTHOUGHNODOUBTTHEREAREBOOKSWHICHDISCUSSANDNEGATEA
IBILITYANDOTHERSWHOSESTRUCTURECORRESPONDSTOTHATOFALADDER.[4]LETIZIAÁLVAREZDETOLEDOHASOBSERVEDTHATTHISVASTLI
USLYSPEAKING,ASINGLEVOLUMEWOULDBESUFFICIENT,AVOLUMEOFORDINARYFORMAT,PRINTEDINNINEORTENPOINTTYPE,CONTAININGA
NITELYTHINLEAVES.(THEEARLYSEVENTEENTHCENTURY,CAVALIERISAIDTHATALLSOLIDBODIESARETHESUPERIMPOSITIONOFANINFI
HEHANDLINGOFTHISSILKYVADEMECUMWOULDNOTBECONVENIENT:EACHAPPARENTPAGEWOULDUNFOLDINTOOTHERANALOGOUSONES;THEINC
OULDHAVENOREVERSE.JORGELUISBORGESTHEGARDENOFFORKINGPATHS1941TRANSLATEDBYJ.E.I.JUBAL.@WESTNET.COM/HYPERDISCO

NIVERSE(
SURROUND
ARIABLE.
EXCEEDST
ST.TOTHE
TIES.ALS
THFULLYD
PREFERTO
THEREARE
OUTH;IHA
AFEWLEAG
LESSAIR;
EALISTSA
TAGONALR
CONTINUO
UFFICENO
LE.THERE
GES;EACH
ONOTINDI
ISCOVERY
THISTRUT
N,MAYBET
ESTAIRWA
,ITISENO
LICATE,P
EEHUNDRE
SANDCHAO
EPEATEDF
PYRAMIDS
ESANDINC
TWITHTHA
TURALSYM
RELYFALL
TMEN,THE
THATNINE
DTOANYLA
UEOFMCVI
RSTHOUGH
NDREDYEA
DHISFINO
ISHED:AS
NALYSIS,
FUNDAMEN
THEPERIO
DENTICAL
ONSOFTHE
EFUTURE,
FTHEFALL
L,THECOM
ERYBOOKI
EMSELVES
THEUNIVE
OOKSOFAP
OFTHEGRE
RIMSDISP
TS,METTH
EFERTOPE
DICATION
IES--THE
HILOSOPH
RFOURCEN
N:THEYAL
ERIESAND
ING.ASWA
THATTHES
HOULDJUG
SEVEREOR
INAFORBI
DEDTHEHE
C,ASCETI
SFRENZYN
IRREPLAC
ACOMMA.C
EFANATIC
OWERFUL,
ED)THERE
ELANGUAG
NTHEMOST
ONSULTFI
NDEREDAN
JUSTONE,
S.LETHEA
ED.THEIM
PTION.TH
EEVERYTH
ABOMINAB
PHICALSY
ISENTITL
STIFIEDI
SOMECHAR
ARTICULA
NTOTAUTO
REFUTATI
ITOUSAND
UE.YOUWH
HATEVERY
STHEIRPA
BLYDEGEN
AGEANDFE
UMINATED
`INFINIT
JUDGEITT
OIMAGINE
THELIBRA
PEATEDIN
SCRIPTDO
-TWOLETT
EVERYTHR
MANYNIGH
OEXIST.O
THISPOSS
S:RIGORO
ERIFINFI
LANES.)T
DLEPAGEW
OF_BABEL

Rony Maltz

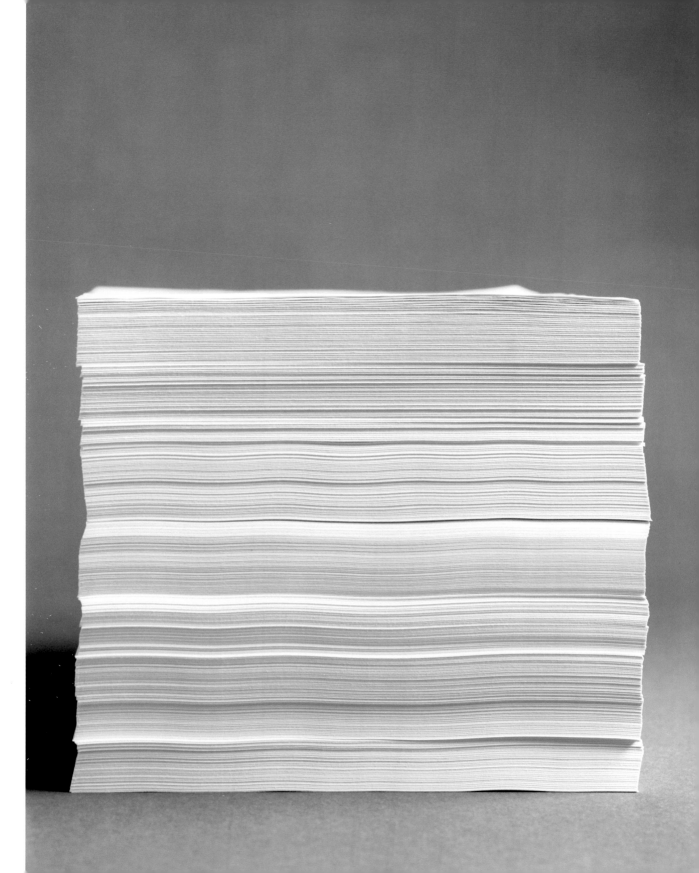

Nandita Raman

PHOTOGRAPHER INDEX

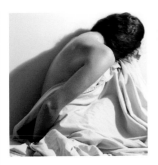

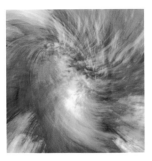

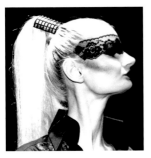
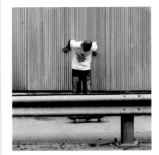

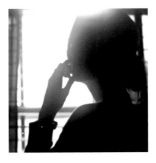

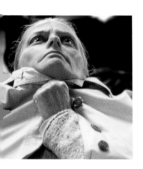

68 / 69
Adhat Campos
GS
646-808-7441
adhatd@gmail.com
adhatd.blogspot.com
Mexico

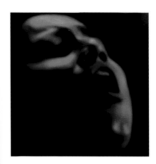

184 / 185
Maya Chandally
GS
917-921-1025
maya.chandally@gmail.com
mayachandally.tumblr.com
United States

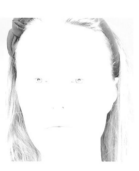

174 / 175
Thierry Casias
GS
917-648-6896
thierry.casias@gmail.com
casias.tumblr.com
United States

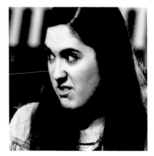

20 / 21
Robin Lee Dahlberg
PJ
917-620-5799
robindahlberg57@gmail.com
www.dahlbergphotography.com
United States

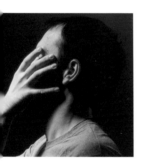

34 / 35
Dominique Catton
GS
917-679-1576
dominiquecatton@gmail.com
www.dominiquecatton.com
Italy, United States

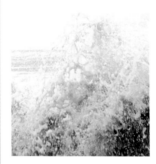

80 / 81
Amina Diaw
PJ
415-531-4032
waidami43@gmail.com
Senegal

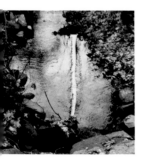

136 / 137
Ashley Cerciello
GS
908-656-7154
ashcerciello@gmail.com
www.ashleycerciello.com
United States

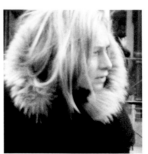

66 / 67
Kelsey Dickey
PJ
202-492-6758
kelsey.dickey@gmail.com
http://kelseydickey.com
United States

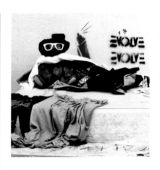

122 / 123
Lucia Fainzilber
GS
347-241-9374
lulufain@gmail.com
www.luciafainzilber.com
Argentina

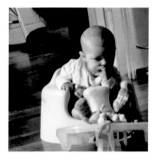

168 / 169
Beth Flatley
PJ
415-407-1803
flatlee@gmail.com
www.bethflatley.com
United States

92 / 93
Kristen Farmer
GS
713-582-9999
kristenfarmerPhoto@gmail.com
www.kristenfarmer.com
United States

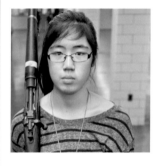

40 / 41
Adrian Jacob Fussell
PJ
512-809-0221
af@adrianfussell.com
www.adrianfussell.com
United States

140 / 141
Andrew Fedynak
GS
804-380-5992
andrew.fedynak@gmail.com
www.fedynak.com
United States

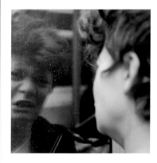

64 / 65
Alessandro Ghirelli
PJ
347-419-5867
Italy (39) 333-910-0578
aleghirelli@gmail.com
www.aleghirelli.com
United States, Italy

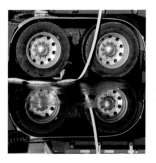

104 / 105
Phoebe Foley
GS
310-463-0406
phoebe.foley@gmail.com
www.phoebefoley.com
United States

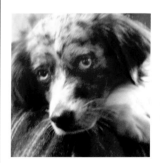

58 / 59
Cassandra Giraldo
PJ
818-943-4732
cassandrarian.giraldo@gmail.com
www.cassandragiraldo.com
United States

44 / 45
Gabriele Giugni
GS
917-680-9622
gabrielegiugni@me.com
www.gabrielegiugni.it
Italy

26 / 27
Helle Harnisch
GS
456-126-0986
helle.harnisch@gmail.com
www.helleharnisch.com
Denmark

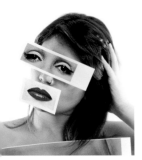

192 / 193
Hannah Gopa
GS
917-690-4805
hannahgopa@gmail.com
www.hannahgopa.com
Brazil

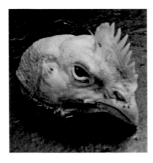

196 / 197
Anita Isola
PJ
917-680-6489
anita.isola@gmail.com
www.anitaisola.in
India

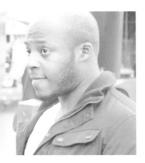

74 / 75
Sina Haghani
MFA
404-502-0160
sina.haghany@gmail.com
www.sinahaghani.com
United States

202 / 203
Michi Jigarjian
MFA
646-221-0748
michi@michij.com
www.michij.com
United States

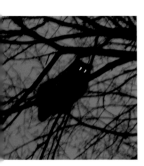

150 / 151
Bjorn Haldorsen
PJ
914-434-6010
bjorn.h.photo@gmail.com
www.bjornhaldorsen.com
Norway

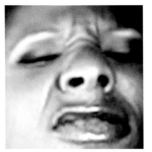

188 / 189
Thomas Law
GS
646-919-7897
thomas@notnotawesome.com
www.notnotawesome.com
United States, Australia

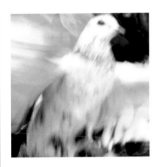

82 / 83
Beth Levendis
PJ
917-306-4579
bethstie@gmail.com
www.bethlevendis.com
United States

48 / 49
Juan José López Juárez
PJ
646-474-2347
Guatemala (502) 5202-8635
juanjoses19@gmail.com
www.juanjlopez.com
Guatemala

70 / 71
Xiaofan Li
GS
716-544-8650
funx914@gmail.com
heyyous123.tumblr.com
United States

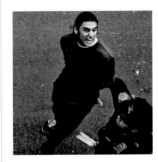

164 / 165
David Lundbye
MFA
347-512-1327
Denmark (45) 711-79660
david@davidlundbye.com
www.davidlundbye.com
United States, Denmark

110 / 111
Di Di Lin
GS
646-696-1629
macdidilin@mac.com
www.lindidi.com
United States, China, Taiwan

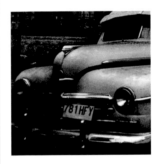

52 / 53
Andre Malerba
PJ
802-779-2998
andremalerba@gmail.com
www.andremalerba.com
andremalerba.wordpress.com
United States

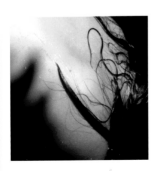

24 / 25
Teresa LoJacono
MFA
805-441-0698
teresalojaconophotography@
gmail.com
www.teresalojacono.com
United States

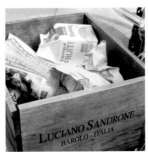

160 / 161
Anna Gabriela Malta
PJ
917-995-3070
Brazil (55) 21-8845-9910
gabriela@agmalta.com
www.agmalta.com
Brazil, United States

204 / 205
Rony Maltz
MFA
646-377-2032
r_maltz@yahoo.com
www.ronymaltz.com
United States

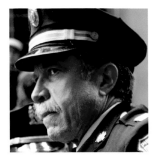

50 / 51
John Anthony Milano
PJ
631-565-0537
jmphoto@johnnymilano.com
www.johnnymilano.com
United States

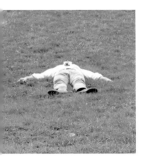

100 / 101
Andrea Manuschevich
GS
917-757-1669
andrea.manu@gmail.com
andreamanuschevich.zenfolio.com
Chile

78 / 79
Freya Ingrid Morales Albalá
PJ
917-399-7893
Denmark (45) 222-789-26
morales.freya@gmail.com
www.freyamorales.com
Spain, Denmark

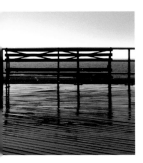

102 / 103
Vittoria Mentasti
PJ
917-679-0766
vittoria.mentasti@gmail.com
Italy

128 / 129
Netza Moreno
PJ
917-744-6063
netza101@yahoo.com
United States

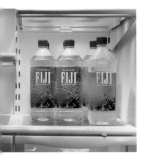

118 / 119
Tatiana Mestre
GS
917-488-5373
Mexico (52) 155-4185-3932
tatianamestre@gmail.com
www.tatianamestre.com
United States, Mexico

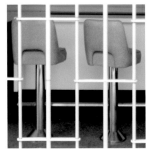

108 / 109
Shayok Mukhopadhyay
PJ
914-843-9608
shayok@shortwork.net
www.shayok.com
United States

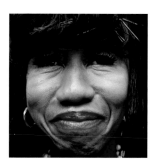

76 / 77
Lene Münch
PJ
347-885-5422
Germany (49) 176-262-70885
mail@lenemuench.de
www.lenemuench.de
www.kollektiv25.de
Germany

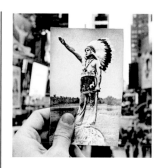

162 / 163
Francesco Palombi
GS
917-832-2301
whatfra@hotmail.it
www.francescopalombi.com
Italy

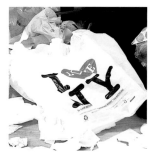

88 / 89
Juan Carlos Munoz-Najar
GS
917-751-4340
Peru (51) 1-445-0503
jcmunoznajar@gmail.com
www.jcmunoznajar.com
Peru, United States

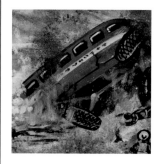

138 / 139
Brian Paumier
MFA
310-809-6873
brian@brianpaumier.com
www.brianpaumier.com
United States

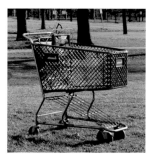

98 / 99
Liang Ni
PJ
917-285-6945
netguysky@gmail.com
www.niliangphotography.com
China

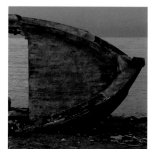

96 / 97
Jorge Alberto Perez
MFA
perez.j.alberto@gmail.com
www.jorgealbertoperez.com
United States

142 / 143
Julie Nymann
GS
454-040-6731
julie@julienymann.com
www.julienymann.com
Denmark

120 / 121
Kenneth Pizzo
GS
347-326-4205
kenneth.pizzo@gmail.com
www.kennethpizzo.com
United States

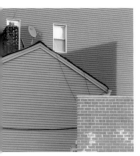

112 / 113
Simone Pomposi
GS
917-822-7433
info@simonepomposi.com
www.simonepomposi.com
Italy

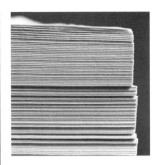

206 / 207
Nandita Raman
MFA
484-479-6081
ramannandita@gmail.com
ramannandita.blogspot.con
United States

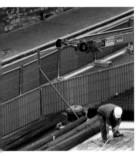

126 / 127
Libby Pratt
MFA
360-809-0242
www.libby@libbypratt.com
libbypratt.com
United States

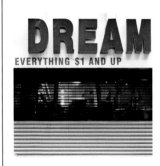

106 / 107
Diana Rangel Lampe
GS
917-822-3523
dianarangel87@gmail.com
www.dianarangel.com
dianarangelphotography.tumblr.com
United States

42 / 43
Ruth Prieto Arenas
PJ
917-744-3737
Mexico (52) 55-5135-5235
prieto.ruth@gmail.com
www.ruthprietophotography.com
Mexico, United States

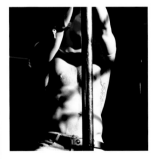

178 / 179
Jan Rattia
GS
404-409-1379
jan@janrattia.com
www.janrattia.com
United States

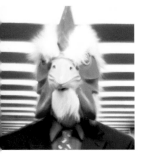

84 / 85
Josh Raab
PJ
617-529-2308
jraab2222@yahoo.com
theraabit.tumblr.com
www.joshraabphoto.com
United States

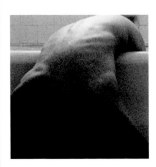

144 / 145
Laura Lee Revercomb
GS
303-501-0181
ivegotmangosinmymouth@gmail.com
www.leerevercombgallery.com
United States

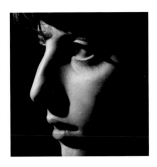

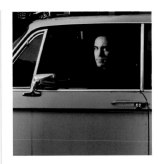

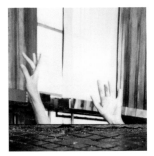

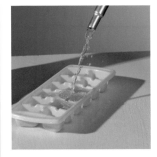

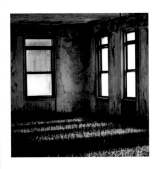

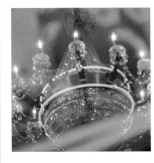

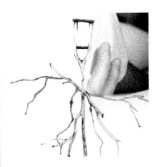

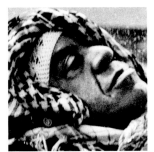

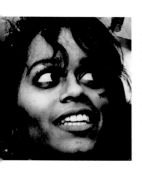

54 / 55
Meredith Rutledge
PJ
203-581-0003
meredith.rutledge@gmail.com
www.meredithrutledge.com
United States

38 / 39
Abhinav Sanghi
PJ
703-625-7820
India (91) 981-0189-948
abhinav.sanghi@gmail.com
pictureonword.wordpress.com
India

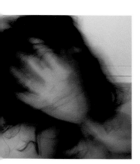

28 / 29
Laura Lee Sabolich
GS
405-596-6421
laura_sabolich@me.com
www.laurasabolichphotography.com
United States

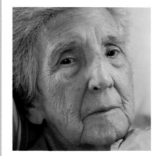

170 / 171
Sarah R P Schuman
PJ
914-760-9894
sarah.schuman@gmail.com
www.sarahschuman.com
sarahschuman.wordpress.com
United States

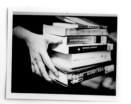
WHEEL

182 / 183
Melisa Salas
GS
347-320-8920
Venezuela (58) 414-110-3338
mcsalas003@gmail.com
www.melisasalas.com
Venezuela

186 / 187
Stephen K. Schuster
MFA
917-837-0450
studio@stephenkschsuter.com
www.stephenkschuster.com
United States

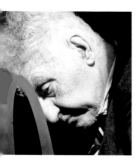

72 / 73
Ramón Ruiz Sampaio
PJ
347-409-1099
Mexico (52) 555-6451766 /
552-7449424
ramonrsampaio@gmail.com
www.ramonsampaio.com
Mexico

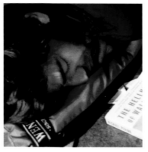

56 / 57
Cory Schwartz
PJ
516-680-3964
coryhschwartz@gmail.com
www.coryschwartz.com
United States

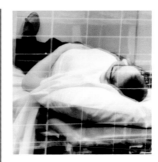

154 / 155
Gaia Squarci
PJ
917-574-6657
gaia.squarci@gmail.com
gaiasquarci@wordpress.com
Italy

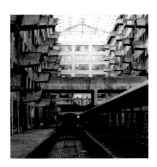

158 / 159
Woong-Jae Shin
PJ
917-838-7448
woongjae.shin@gmail.com
www.wjshinphotography.com
United States, South Korea

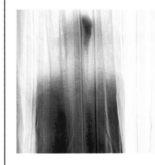

32 / 33
Elisabeth Stiglic
GS
808-237-0863
huldra70@hotmail.com
www.elisabethstiglic.com
Norway, Denmark

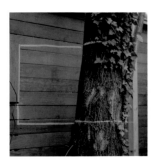

114 / 115
Sara Skorgan Teigen
GS
646-384-8379
sarasteigen@gmail.com
www.saraskorganteigen.com
United States, Denmark, Norway

200 / 201
Daniel Temkin
MFA
917-903-8570
daniel@danieltemkin.com
http://danieltemkin.com
United States

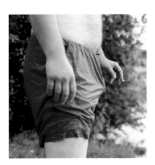

94 / 95
Peter Snadik
MFA
917-250-7813
Slovakia (42) 1-907-353287
petersnadik@gmail.com
http://snadik.tumblr.com
Slovakia

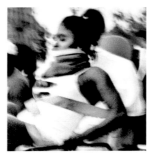

60 / 61
Daniel Tepper
PJ
617-595-8245
danieltepper.photo@gmail.com
www.danzev.com
United States

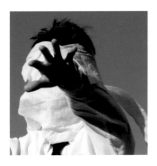

16 / 17
Elena Soboleva
PJ
276-206-9456
soboleva@gmail.com
www.soboleva.name
Russia, United States

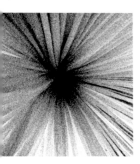

180 / 181
Min-Wei Ting
GS
347-987-0277
contact@mwting.com
www.mwting.com
Singapore, United States

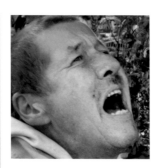

132 / 133
Russ Voss
PJ
201-983-9516
russvoss@gmail.com
www.russvoss.com
United States

190 / 191
Roberta Trentin
GS
917-969-6912
robertatrentin@gmail.com
www.robertatrentin.com
rtrentin.tumblr.com
United States

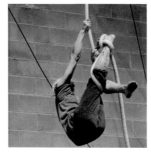

176 / 177
Diane M Walton
PJ
917-445-3895
dianemwalton@gmail.com
www.dianemwalton.com
United States

156 / 157
Satoshi Tsuchiyama
GS
917-216-9086
satoshi85@gmail.com
www.satoshitsuchiyama.com
United States

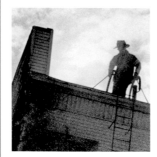

124 / 125
Andrew White
PJ
310-339-2302
andrewwhite.86@gmail.com
www.andrewdwhitephoto.com
United States

62 / 63
Oliver Tucker
PJ
646-538-7994
opwt@mac.com
www.olivertucker.com
United Kingdom

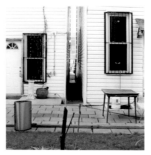

116 / 117
Helena Wolfenson
PJ
718-708-1402
helenawolfenson@gmail.com
amargemdaimagem.tumblr.com
United States, Brazil